Pet Photography 101

Tips for Taking Better Photos of Your Dog or Cat

Andrew Darlow

ELSEVIER

AMSTERDAM • BOSTON • HEIDELBERG • LONDON
NEW YORK • OXFORD • PARIS • SAN DIEGO
SAN FRANCISCO • SINGAPORE • SYDNEY • TOKYO

Focal Press is an imprint of Elsevier

Focal
Press

Focal Press is an imprint of Elsevier
30 Corporate Drive, Suite 400, Burlington, MA 01803, USA
Linacre House, Jordan Hill, Oxford OX2 8DP, UK

Notices
Knowledge and best practice in this field are constantly changing. As new research and experience broaden our understanding, changes in research methods, professional practices, or medical treatment may become necessary.

Practitioners and researchers must always rely on their own experience and knowledge in evaluating and using any information, methods, compounds, or experiments described herein. In using such information or methods they should be mindful of their own safety and the safety of others, including parties for whom they have a professional responsibility.

To the fullest extent of the law, neither the Publisher nor the authors, contributors, or editors, assume any liability for any injury and/or damage to persons or property as a matter of products liability, negligence or otherwise, or from any use or operation of any methods, products, instructions, or ideas contained in the material herein.

∞ Recognizing the importance of preserving what has been written, Elsevier prints its books on acid-free paper whenever possible.

Library of Congress Cataloging-in-Publication Data

Darlow, Andrew.
 Pet photography 101: tips for taking better photos of your dog or cat / Andrew Darlow.
 p. cm.
 Includes index.
 ISBN 978-0-240-81215-1 (pbk. : alk. paper) 1. Photography of animals. I. Title.
 TR727.D393 2009
 778.9'32–dc22
 2009024691

British Library Cataloguing-in-Publication Data
A catalogue record for this book is available from the British Library.

ISBN: 978-0-240-81215-1

For information on all Focal Press publications
visit our website at www.elsevierdirect.com

10 11 12 13 5 4 3 2

Printed in China

This book is dedicated to the memory of Chachi, Cupid, Jiro, Lady, Madel, Muffet, Penny, Regal, Shaney, and the many other dogs and cats who have made an impact on my life, as well as the lives of so many others. We miss you.

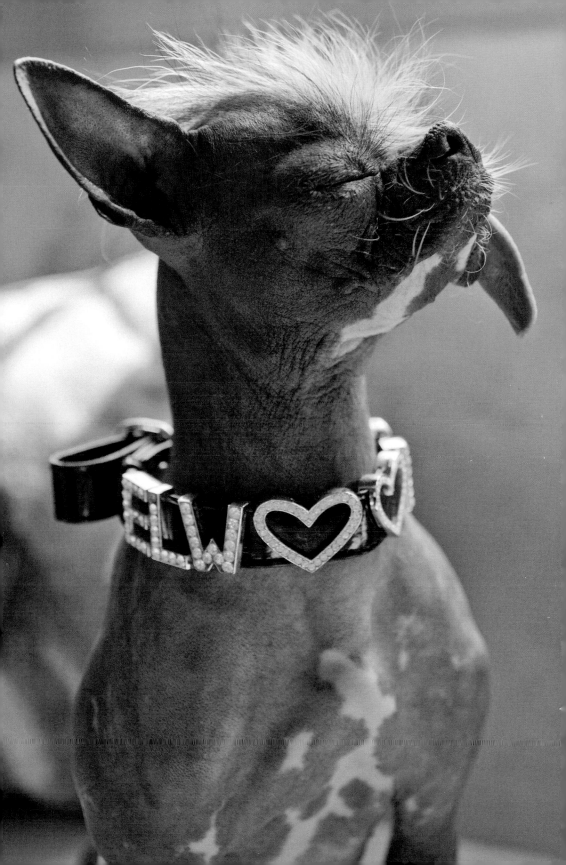

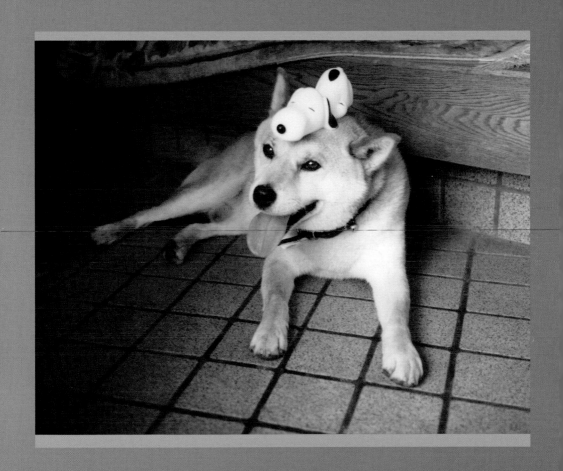

Who This Book Is For

This book was designed primarily for those who want to make better photos of pets and people, regardless of your photographic or computer skill level. The book was designed to give you the information needed to get started or to continue on your journey toward making better photographs in many different situations—from simple but dramatic photos of a pet just waking up in the early morning sunlight, to a family photo on the beach in the late afternoon, lit with the help of a portable flash unit. I wrote the book with as little jargon as possible, and in many cases, when I wanted to elaborate or include more information about a topic, I created a reference link, which you can find on the book's companion Web site.

Companion Web Site

The Internet offers an incredible amount of free and fee-based information about photography, digital imaging, dogs, cats, and just about every related topic. The book's companion Web site (*www.PhotoPetTips.com*) contains hundreds of links to more information related to the tips presented in this book, as well as additional information about photography, retouching, and much more. Just look for notations like [w1.1] throughout the book. I created these reference links to reduce the number of Web URLs that would otherwise have to be printed throughout the book. The links also reduce the amount of typing necessary to get to the information. To navigate to a link, just click on the chapter number on the main page of the companion Web site, and then click on the specific link reference number.

What You'll Need

To get started, you'll need a camera, though even a camera phone will do. In Chapter 1 I explain why I prefer digital single-lens reflex cameras (DSLRs) for most of my image making, but you'll also see why a good-quality point-and-shoot camera or video camera with a still picture mode may be perfect for all your needs. It's all about making pictures that you and your family can enjoy, and not about how many megapixels you can capture, or how many pounds of

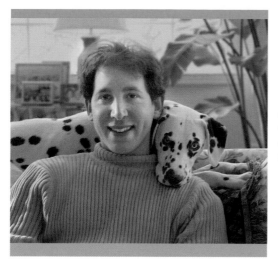

Andrew Darlow relaxing with one of his four legged models at a client's home after a photo session. Photo by David Levy.

Darlow is editor of *The Imaging Buffet* (*www.imagingbuffet.com*), an online resource with news, reviews, and interviews covering the subjects of photography, printing, and new media. His book *301 Inkjet Tips and Techniques: An Essential Printing Resource for Photographers* (Course Technology, PTR) was chosen as the winner in the "Photography: Instructional/How-To" category of The National Best Books 2008 Awards, sponsored by USA Book News.

For more information and to see more of Andrew Darlow's work, visit (www.andrewdarlow.com).

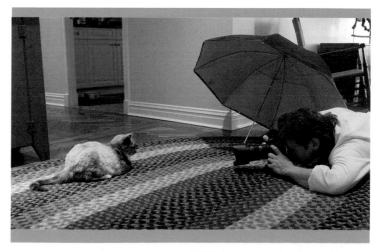

Andrew Darlow photographing a client's cat in New York City. Photo by Paul Kessel.

Andrew Darlow
Photo by Jorge Julian

Andrew Darlow is an award-winning author and photographer whose love of cats and dogs began at a very young age. His pet photography has been featured in numerous publications and on-air broadcasts, including *Animal Fair* magazine, the *News 12 New Jersey* television program, *Rangefinder Magazine*, and the *AKC Gazette* (the official magazine of the American Kennel Club).

Over more than a decade, Darlow has been commissioned to photograph people and their pets in both formal and informal situations. He has photographed numerous dog shows, including the Westminster Kennel Club Dog Show in New York City, and he has donated his photo and custom-printing services to a number of causes, including the Susan G. Komen Foundation, Women's Venture Fund, The Seeing Eye (the world's oldest existing dog guide school), and the garden tour for Animal Rescue Fund of the Hamptons (a no-kill shelter for dogs and cats). He has lectured and conducted seminars and workshops around the world at conferences and for photography organizations and schools, including the Arles Photo Festival; School of Visual Arts, Columbia University; and the International Center of Photography (ICP) in New York.

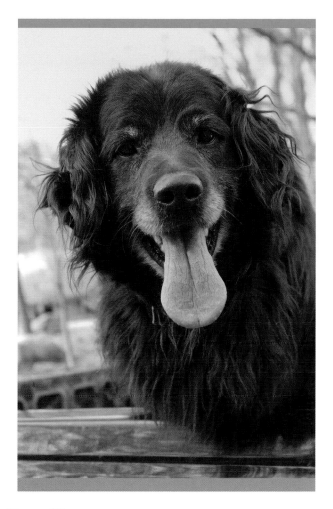

Camera: Canon EOS-D60;

Lens/Focal Length: Canon 50 mm macro;

ISO: 400; *Aperture:* f/4.5;

Shutter Speed: $\frac{1}{250}$ sec;

Lighting Notes: Natural daylight from the sun low in the sky provided all of the lighting. The primary catch light in the dog's left eye is the reflection of a boat covered with an off-white tarp, parked in the driveway. The catch light was then cloned to enhance the overall look of the image using Adobe Photoshop.

photo © Andrew Darlow

gear you can carry. A late-model computer running Mac OSX or Microsoft Windows is highly recommended, though not necessary thanks to the many resources available today at photo labs and retail stores.

With regard to software, I mention Adobe Photoshop a lot throughout the book because I utilize the program in some way for much of my retouching and image preparation, but Adobe Photoshop is not necessary to perform the vast majority of what I cover and demonstrate in the book. Also, unless otherwise noted, when I mention Adobe Photoshop, I am speaking of Adobe Photoshop CS2/CS3/CS4, etc. In Chapter 9, Tips 85 and 86, I discuss a few free and inexpensive retouching software options, as well as some powerful image-processing programs (Apple Aperture and Adobe Photoshop Lightroom) that work differently from Adobe Photoshop, and that should be considered by anyone who is serious about photography and who would like to work more efficiently.

xiii

About the Cover Image

On the following page is the unretouched version of the book's cover photo. I took this photograph of a beautiful 11-year-old Labrador-mix on a clear day at about 5:30 P.M. in April. The dog's owner placed her in the back of his pickup truck, which raised her position and allowed me to photograph her without having to crawl around on the ground—not that there's anything wrong with that!

As is the case with most of the photos in the book, there are multiple tips from the book that are represented in the image, and some minor retouching was done to produce the final image. Apart from cropping the photo for the cover, selective sharpening was done on the dog's eyes and fur, and some contrast enhancement was done on the dog's eyes by first selecting them and then using the curves tool in Adobe Photoshop. Also, a catch light was added to the dog's right eye by cloning it (brushing in the detail by copying it from another location) in Adobe Photoshop using the catch light in her left eye. I've included the before image here because I believe that these small adjustments to her eyes alone have a dramatic effect on the overall image. You can use a similar process to improve the photos in your collection that might benefit from the same techniques.

Contents

Photography is an art. The ability to set the scene, capture the moment, and have others connect with the emotion and beauty of the picture is what makes a photographer great. As an amateur photographer, I love taking pictures of my favorite subjects … my four-legged family. The walls in my home are covered with pictures of my pets, and nothing gives me more joy than seeing their faces throughout my house as I move from room to room. Anyone who has shared a special love with an animal knows what I mean. They come into our lives for a relatively short time, and when they are gone, our hearts ache. But they can live on forever in their photos, and their pictures are often a source of great comfort when they leave us.

Andrew Darlow is one of those rare photographers who have a talent to see things through a tender eye. He is passionate about his work. He has sensitivity toward animals and people that is transparent in his photography. I met Andrew after my dog, Elwood, won the 2007 World's Ugliest Dog Contest, and lucky for me, Andrew was quite interested in photographing Elwood and the rest of my family. Andrew spent hours at my home painstakingly photographing Elwood, as well as my other furry "kids." When Andrew sent me the proofs I was overwhelmed; the photos he took were the most beautiful pictures of Elwood I had ever seen. He captured Elwood's true "beauty." Andrew saw the gentleness of the little dog I fell in love with when I first rescued him, and through his lens, he brought out Elwood's tenderness and splendor, as well as the special bond that Elwood shares with everyone in our home. The photos were artistic, beautifully composed, and just lovely.

Pet Photography 101 will allow photographers of any level to hone their skills with easy-to-understand information and techniques. Many of the "models" featured in the book are rescued animals that were once homeless. Now they are special, loving companions for many families. Thank you, Andrew, for sharing your talent with others and for bringing beauty to the world through your magnificent photography.

Karen and Elwood Quigley,
Sewell, New Jersey

www.EveryoneLovesElwood.com

Karen Quigley with Elwood and some of the other adopted members of her family (all of whom are rescues). Photo © Andrew Darlow

I love photography. And as long as I can remember, I've loved sharing time with and photographing dogs and cats. Throughout my childhood, I spent hours playing with many dogs and cats at the homes of family and friends. Later in life, at the age of 18, I lived with a family in Japan, where I shared the house with a very special Akita named Jiro (see the following page for more about Jiro). Since then, I've spent time with and have had the honor of photographing hundreds of dogs, cats, and their people friends from New York City to Tokyo, Japan.

Whether I'm photographing a dog or cat while on vacation, on the front lawn of a neighbor's house, or during a commissioned assignment at a client's home, I find that my most memorable photos are not posed pictures with a paper or fabric background. They are the pictures that happen spontaneously, like a photo of a dog's face with his tail wagging happily when he reacts to the voice of a family member, or a photograph of a cat while she's in a zenlike state of relaxation perched on a window sill. I always strive to capture the spirit of pets and the people with whom they share their lives.

And that's my goal for this book—to help you make better photographs of your loved ones that you and your family will cherish for many years. If you take even one photo that is influenced by what you read here, and if that image brings a tear to your eye or a smile to your face, then I've done my job. Hopefully, you'll be making many more than just one memorable photo, filling digital or actual photo albums and frames using the advice contained in the book.

I have so many people (and furry friends) to thank for helping make this book possible. To help express my gratitude, I've included an acknowledgement section on the companion Web site. It also contains links to more information about many of the people (and of course, the pets) who have made a positive difference in my life.

How the Book Is Organized

This book is organized in nine chapters and 101 tips, beginning with information about different cameras, lenses, and the nuts and bolts of photography, including color balance, removable card storage options, and various shooting modes. Most of the book's chapters center on a theme, such as lighting and creative photography, with tips related to that theme. To help illustrate the tips, most of them are accompanied by one of my photographs and a description of the overall setting, as well as camera shooting data (for example, shutter speed and ISO). Also included with most of the tips is a description of the lighting used, including from where the sun and/or other lighting is coming.

Important note: In most cases, I've also included the month and time of day that the photos were taken to help you better determine when you might find a certain quality of light. Unless otherwise stated, all photos were taken in the northeast United States (New York/New Jersey area), which is important to know since natural light will generally be different in other regions of the world at different times of the year.

Jiro (my "host family dog"), photographed in Nara, Japan. Jiro means "second son" in Japanese, and he quickly became like a second host brother to me when I lived with a wonderful host mother, father, sister, and brother in Japan as an exchange student. In this photo, Jiro looks quite pleased with the small gift I gave to him earlier that day. There are a few tips from the book at work here, including:

- *Tip 60:* Capture some interesting profile or partial-profile views. Your subject doesn't always have to be looking right at the lens, as you can see from this photo.
- *Tip 89:* Get your old negatives, slides, and prints scanned (or scan them yourself). I scanned this photo from a 4 × 6-inch (approximately 10 × 15-cm) print on an inexpensive flatbed scanner.
- *Tip 93:* Sharpen with care (sometimes selectively) depending on the subject. For this photo, the entire image was sharpened moderately, but I selectively sharpened Jiro's eyes and fur to help draw attention to those areas.

Train Your Camera, but Don't Make It Roll Over!

Great photos of dogs and cats can be found almost everywhere, including magazines, billboards, and greeting cards. But getting similar image quality and expressions from the pets you share your life with can be a challenge. I'm here to help. In this chapter I cover some of the basics of photographing dogs, cats, and the people who love them, including camera selection, accessories, and ways to get started quickly, regardless of your camera or current experience level. I also reference some of the images and content in other chapters of the book, as well as Web sites that relate to the tips presented. So without further ado, and with a friendly bark and a meow, on with the tips!

Please note: When you see notations like [w1.1], it means that a related Web link (and usually additional information) can be found by visiting the book's companion Web site at *www.PhotoPetTips.com*.

Important note: Also included with most of the tips is a description of the lighting used and the month and time of day that the photos were taken to help you better determine when you might find a certain quality of light. Unless otherwise stated, all photos were taken in the northeast United States (New York/New Jersey area).

Photo on facing page © Andrew Darlow [see Tip 1 for image information]

Tip #1

Choose the right camera for your needs (and the needs of your pets)!

You'll definitely need a camera of some type to take photographs, so that's why this is the first official tip of the book. Overviews of the five most popular types of cameras used today are described below. Because there is so much I'd like to cover within each category, I go into more detail with all the camera types listed below in an article available on the book's companion Web site [w1.1].

Some cameras made today can be placed in multiple categories, but most people consider these to be the major categories:

- Film Cameras: Most people (including me) learned photography using film cameras. Film cameras have been produced for over 100 years, and many types and models have been made. These include: Single-use plastic film cameras; Point-and-shoot 35mm film cameras; 35mm SLR (Single Lens Reflex) film cameras; and specialty film cameras, including swing-lens panoramic cameras that can produce some amazing images. Other options include pinhole cameras, as well as the Holga and Diana+, which help to produce very artistic images that must be seen to be believed [w1.2].

- 35mm DSLRs: 35mm DSLR's have become the most popular camera type for professional photographers, and many non-pros also use them because of the many features they offer [w1.3].

- Digital Point-and-Shoot Cameras: Excluding camera phones, digital point-and-shoot cameras are the most popular category of digital camera. One of the main features most digital point-and-shoot cameras have that most DSLRs lack is video, but that gap is closing fast.

- Video Cameras with Still Photo Modes: There are many video cameras on the market today that have very good–quality still picture modes, and the lines are blurring between video cameras and point-and-shoot still cameras [w1.4]. Please also note that when I refer to point-and-shoot cameras in this book,

I am also referring to most video cameras with still photo modes.

- Camera Phones: The popularity of the camera phone is nothing short of incredible. Whereas just a few years ago only a small percentage of the population carried a camera, today over a billion people worldwide have a camera at their side, integrated into their phone/smartphone. The quality of camera phones varies dramatically. Some are even capable of producing images that rival the image quality of good quality point-and-shoot digital cameras [w1.5]. Some tips for using camera phones can be found later in this tip.

3

Before making a camera purchase, it often helps to read the advantages and disadvantages of one type of camera compared with another. I've put together a few detailed articles on the book's companion Web site that compare the cameras discussed throughout this section [w1.6]. For example, most DSLRs have a traditional optical viewfinder instead of just a video representation of what you are about to capture, as found on most point-and-shoot cameras. That can be helpful because the built-in diopter that accompanies most optical viewfinders can be easily adjusted for your shooting eye. Also, putting the camera against your face when shooting can help stabilize it. Having a true optical viewfinder can also make manual focus and burst-mode photos in quick succession of a moving subject (like a jumping cat) much easier.

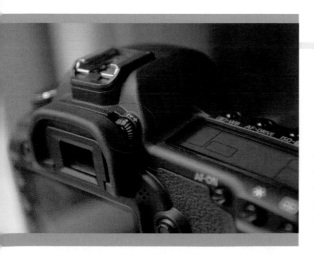

The diopter adjustment dial on the Canon EOS-5D Mark II DSLR (circled in red) is similar to the diopter adjustment on most cameras that have an optical viewfinder. Above the viewfinder is the camera's hot shoe for mounting flash units and/or wireless trigger devices.

photo © Andrew Darlow

For this photo of Elwood, photographed on a sunny May afternoon at about 3 P.M., I asked him to sit on a bench near a window, and he soon discovered what a nice spot it was to soak up some rays. I show this image to demonstrate some of the advantages DSLR cameras have over most point-and-shoot cameras. First, I'm using a super-sharp 50mm macro lens, which I discuss more in Tip 3. It is of higher quality and has wider maximum aperture compared with most point-and-shoot camera lenses. Next, I shot the image at ISO 640, which results in considerably more grain on most point-and-shoot cameras. Finally, the DSLR I used shoots at a faster frame rate, and I'm able to capture more images without having to wait for the camera's buffer to catch up compared with just about any other point-and-shoot camera. That's not to say that you can't get great images and good frame rates with a point-and-shoot camera. It just helps sometimes to see why people go out of their way to carry and use DSLRs (and in some cases, multiple lenses).

Camera: Canon EOS-5D;
Lens/Focal Length: Canon 50mm;
ISO: 640; *Aperture:* f/3.5;
Shutter Speed: $\frac{1}{800}$ sec;
Lighting Notes: The lighting for this photo comes almost entirely from the windows just above Elwood's head, though I used a white board clamped to a light stand (camera left) as a fill card to direct the light coming into the room back toward Elwood.

photo © Andrew Darlow

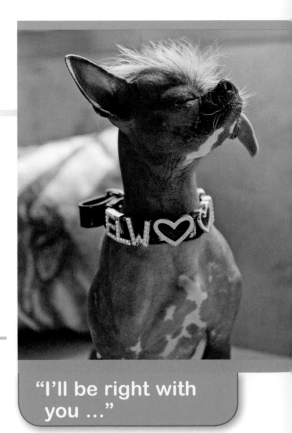

"I'll be right with you ..."

I took this photo of a friend's fun-loving Beagle with a 10-megapixel Canon point-and-shoot digital camera at about 2 P.M. on a May afternoon. A photo of the same dog photographed in similar lighting (but not shaded under trees) can also be found in this chapter.

5

Camera: Canon PowerShot SD790 IS;
Lens/Focal Length: Built-in 6.2–18.6mm IS/14mm;
ISO: 320; *Aperture:* f/4.5;
Shutter Speed: $\frac{1}{500}$ sec;
Lighting Notes: Lighting was natural daylight filtered by trees.

photo © Andrew Darlow

"A little to the left....
Perfect!"

This photo of the same Beagle was shot in the parking lot of a restaurant with an Apple iPhone 3G. The overall quality is surprisingly good for a smartphone camera. I ran the "reduce noise" filter in Adobe Photoshop on the dark portion of the dog's fur to reduce some of the color noise in the photo.

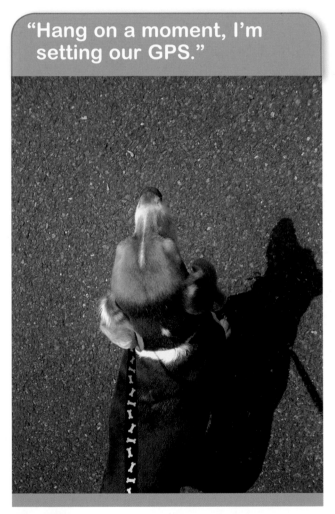

"Hang on a moment, I'm setting our GPS."

Camera: Apple iPhone 3G;
Lens/Focal Length: built-in;
Aperture: f/2.8;
Shutter Speed and ISO: unrecorded;
Lighting Notes: Lighting came entirely from natural daylight.
photo © Andrew Darlow

A Few Camera Phone Tips

- In the camera settings menu (if your camera phone has one), set it to the highest native picture resolution and quality if you want the best possible results. The highest resolution shown is usually the native resolution, and the manual should note if it is not.

- If your camera has a slot for external memory, such as a micro SD card, buy a card and set the camera to record to the external card. Then purchase a card reader, or use the one built into your computer if you have one (an SD card adapter is usually included with every micro SD card). It will allow for much faster transfer speeds, and will avoid potential data charges from your cell carrier.

- Turn off the camera phone's internal flash (most of them do a poor job) and go outside during the day to shoot, turn the lights on in your home, or use continuous lighting such as a lamp or diffused LED light for better overall results [w1.7]. See Chapter 8 for much more about lighting.

- Use your opposite hand (the hand not holding your phone) to cradle and help stabilize your phone while taking pictures. This can dramatically improve sharpness, especially in low light situations.

I took the photo on the following page of a friend's black-and-white cat in low light with an LG enV cell phone. The camera provided little metadata for the image, resulting in none of the shot information (aperture, shutter speed, etc.) being recorded. However, I was able to choose the white balance setting, and I opted for "Daylight" because the LED light I used was similar to daylight (about 5500 degrees Kelvin–see Tip 4 for more about color temperature). The largest file size (1600 × 1200 pixels) was selected in the camera's menu.

7

> ## "Did I just hear the dinner bell ring?"

(a)

(b)

(a) The LED headlamp that I used for this picture can be seen above in Figure (b). I taped a piece of warm-colored diffusion material over it to soften the light and to create a warmer overall tone. Most of the light came from the LED headlamp, which was held about 3 feet (91cm) from the cat. Both photos were taken with the LG enV cell phone.

photos © Andrew Darlow

Tip #2

Decide Whether You Want to Shoot in RAW, JPEG, or Another Mode

The decision to capture your images in RAW, JPEG, a combination 9
of the two, or another mode is an important one. Shooting in your
camera's RAW format gives you the ability to edit your images
more effectively. I generally shoot RAW files only and process my
files through a RAW processing application so that I don't have to
store and archive multiple originals. However, there are reasons
why you might choose to shoot JPEG only, or RAW plus JPEG.
The main reasons for shooting both RAW and JPEG at the same
time are the following:

- You can quickly make an online gallery from the JPEGs and
 email the files without having to process them (though they
 may be quite large if not resized).
- You can bring the JPEGs on a media card or CD (or in some
 cases, a DVD) to a photo lab (or use your own inkjet printer)
 to make prints without having to process them in a RAW
 processing application. If the photos are important, I'd highly
 recommend backing up the files in two places, such as your
 computer and an external hard drive, before inserting your
 card into any photo lab machine.
- You can achieve a secondary backup of your images, and this
 is especially helpful for people with cameras that have two
 separate memory card slots. The camera can be set so that
 one card can be used for RAW files and the other for JPEGs.

More on this topic can be found in Chapter 8, Tip 71. Also included
there are some of the reasons why a JPEG-only workflow may be
right for you.

Tip #3

Consider your lens options carefully (Warning: This can get expensive!)

The number of lens options currently available (especially for DSLRs) is staggering. This is a topic that is discussed widely in many books and online, and I've put together some links to sites that specialize in lens ratings [w1.8], as well as a comprehensive article to help you determine what things to consider before buying a lens [w1.9]. For virtually every photo in this book, you will see information about the focal range and focal length of the lens I used. Keep in mind the "multiplier effect" when you read the lens info. If you use a 50mm lens on a full-frame 35mm DSLR like a Canon 5D, the same lens will approximate the focal length of a 75mm lens in 35mm terms on a smaller, APS-C-sized sensor camera such as the Canon 20D or Canon 50D.

Some point-and-shoot cameras have accessory lenses available that either replace the existing lens or screw onto the front of the lens. This can make for very nice effects, such as a fisheye look (great for close-ups of dogs) or a telephoto option that extends the lens' zoom capability.

While we are on the topic, whether you have a full-frame or a DSLR with a smaller sensor, I recommend considering a fixed–focal length 50mm lens. These lenses are light, compact, and affordable; good-quality models with wide maximum apertures (f/1.8 to f/2.8) are available for about U.S. $100–200. If you check the camera info, you'll notice that quite a few of the photos in this book were shot with a 50mm lens [w1.10].

Macro lenses (or cameras with a macro mode) allow you to create close-up images that are in focus. On point-and-shoot cameras and video cameras, a flower icon is generally used as the symbol to engage the macro shooting mode. Another option that I've used to make macro images are screw-on close-up lenses, which are compatible with DSLR lenses, as well as some point-and-shoot lenses. These attach to existing lenses, are very affordable, and they can also be used for pets, though you will generally need to

get within about a foot of your subject for them to work properly. That makes them great for images of sleeping dogs or cats, and a tripod is recommended to help you get sharper photos. Sometimes a step-down adapter ring is needed to make them fit your particular lens or camera [w1.11].

Other options worth a look are the lenses from LensBaby [w1.12]. They make multiple models for DSLRs and other cameras that allow for creative focus similar to what you can produce with view cameras. The lenses take a bit of practice to get used to, but once you play with them for a little while, you will quickly see how they can help you produce images with a very interesting look and feel.

I photographed the two images of a Soft Coated Wheaten Terrier shown on the next two pages from the same spot with a Tamron 18–200mm lens on a Canon EOS 20D at about 8 P.M. in June. The camera's sensor is not a full-frame 35mm size, and its multiplication factor makes it approximately equivalent to a 30–320mm lens in 35mm terms. I should note that the wide-angle image is not cropped, and about 10 percent of the top and 10 percent of the bottom of the close-up view have been cropped.

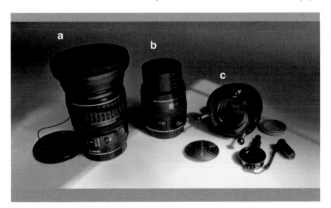

From left to right: (a) Canon EF 28–135mm f/3.5–5.6 IS zoom lens with a Sima CapKeeper 2 attached. The CapKeeper 2 attaches to the barrel of a lens and the front of your lens cap to help keep the lens cap from being misplaced. Attached to the front of the lens barrel is a screw-on collapsible rubber lens shade (available from a number of different companies). (b) Canon EF 50mm f/2.5 Compact Macro Autofocus Lens with the barrel fully extended to the 1:1 Macro level. (c) The Lensbaby 3G and accessories. The Lensbaby Control Freak is an updated version of the Lensbaby 3G.

photo © Andrew Darlow

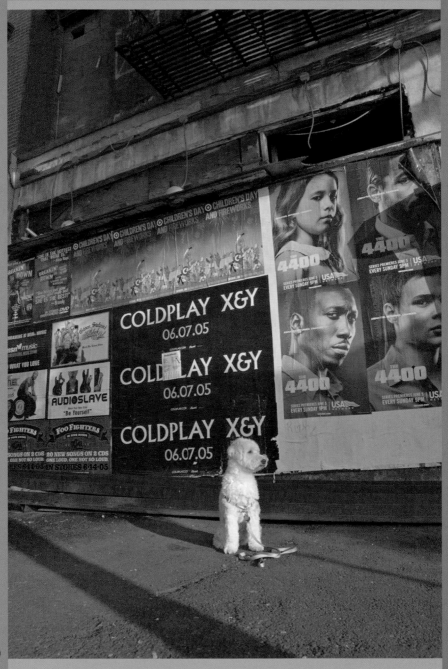

(a)

"Next stop, Hollywood!"

"Now someone just needs to pack my bags for me!"

(b)

13

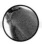

(a) Camera: Canon EOS 20D;
Lens/Focal Length: Tamron 18–200mm Di II/18mm;
ISO: 400; *Aperture:* f/10;
Shutter Speed: ½₀₀ sec;
(b) Camera: Canon EOS 20D;
Lens/Focal Length: Tamron 18–200mm Di II/200mm;
ISO: 400; *Aperture:* f/10;
Shutter Speed: ½₀₀ sec;
Lighting Notes: The lighting for both images is coming from the early evening setting sun, as well as an off-camera diffused flash (placed slightly camera right).
photos © Andrew Darlow

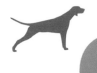

Tip #4

Take control of your color temperature and learn how to set gray balance

14

Color temperature is an important consideration in photography. By learning what types of light have what approximate color temperature, you can more easily choose a color temperature and balance your lighting. For example, daylight at about noon in New York City in the summer is approximately 5500°K (Kelvin), and most traditional lightbulbs and gallery halogen spotlights are about 3500°K. If you were to photograph a scene under those two lighting conditions, you would generally choose the daylight color temperature setting for the 5500°K light and the tungsten color temperature setting for the 3500°K light. When you do that (in a perfect world), all the neutral colors (grays) in your photo will be reproduced as neutral.

Alternatively, you can use a gray or white card of some type to make a custom white balance, as long as your camera has the capability. There are many gray cards on the market, from very small ones that are integrated into lens caps, to large black, white, and medium gray cards that are also collapsible reflectors [w1.13]. Here's a quick tip: If you don't use a custom white balance, set your camera to the "cloudy" white balance setting (look for the cloud icon) when shooting outdoors. It is an excellent starting point that will give most of your outdoor photos (or window light photos) a slightly warm tone, which is great for photographing pets and people.

More info on white balance can be found in an article on the book's companion Web site [w1.14], and additional links to articles on color temperature and filters can also be found there [w1.15].

Tip #5

Learn Your Camera's Various Shooting Modes

Most point-and-shoot cameras (and some DSLRs) have a number of special camera shooting modes (for example, Canon calls them "special scene modes") to help you take pictures in certain situations without having to set the camera manually. Examples include: Landscape, Portrait, Beach, and Night Portrait, and each generally has a descriptive icon, such as a face, runner, or mountain. These can be helpful to know, and are worth learning about, especially if you are not concerned about the science behind the modes. The best way to learn about what each mode does is to refer to your camera's manual or books/Web sites that go over each mode step by step [w1.16]. Also check whether specific modes will force your camera into JPEG shooting mode. You may not want that.

Many point-and-shoot and DSLR cameras have color modes that you can set that allow you to shoot in black-and-white (B&W), sepia, negative, etc., but I would discourage the use of them because you usually will be discarding the color information in your images. Instead, you should shoot in color mode. You can always make adjustments to your images in the computer or even at the lab where you bring your card or CD for output [w1.17].

Other picture modes available on many point-and-shoot and DSLR cameras allow adjustments to overall contrast, sharpness, and saturation in your images. These adjustments generally won't change your RAW files (they can later be reset to defaults in a RAW processing application), but making adjustments to these modes will affect your JPEG files, so consider that before you make adjustments to your camera's settings [w1.18].

Some common shooting modes that can be found on most DSLRs and many point-and-shoot cameras are Program, Auto, Manual, Aperture Priority and Shutter Priority. I cover the last three in more detail in the following two tips.

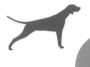

Tip #6

Use Aperture Priority Mode or Manual Mode to Control Depth of Field

16

Aperture priority mode is an extremely powerful and creative way to control the look of your photographs. When I shoot using available light, I almost always have my camera set to aperture priority mode (the symbol for it is usually A or Av, depending on the camera model). The reason I like this mode is because I like to control the depth of field in my photos. Aperture priority adjusts your shutter speed for you based on your camera's meter readings as you change the f-stop on your camera.

Keep in mind that if you set the aperture to a level that causes the shutter to adjust to a very slow speed, your images may be blurred, and that can lead to out-of-focus puppies and kittens. To remedy this, you can add more light, set your ISO to a higher level, or open the aperture to a wider f-stop (for example, from f/8 to f/4).

Manual mode puts a lot of control in your hands, and many photographers use this mode almost exclusively. For cameras that have no built-in internal meter, like the Hasselblad medium format film camera I used for the photo in this tip, you can either guess the exposure, use a hand held meter, or you can use a camera with a built-in meter to get a pretty accurate reading which you then set on the camera that has no meter. Manual mode on many point and shoot cameras is not entirely manual (many cameras will still use their built-in meters and will do their best to make proper exposures). Check your specific camera to see what options are opened up to you when you switch to "M."

An example of how I used a wide aperture to control depth of field can be seen in the photo on the facing page. I focused on the back of the head of a Chihuahua on a street in New York City and shot with an f/2.8 aperture. In the photo, the background is very much out of focus, and parts of the foreground are also out of focus because I chose such a wide aperture. If I had changed the aperture to f/8, the look of the out-of-focus areas would have been different—more of the scene would have been sharp.

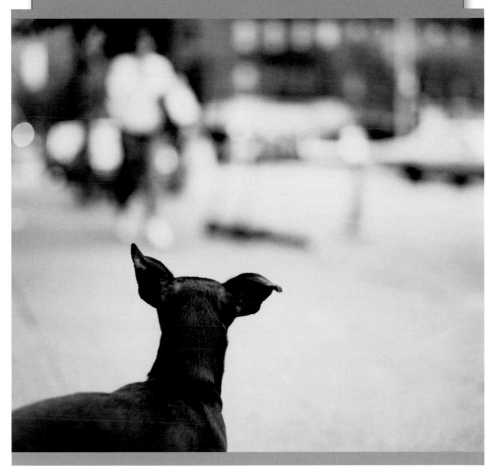

"Finally, my lunch order has arrived."

Camera: Hasselblad 500ELX;
Film: Ilford XP2 B&W film;
Lens/Focal Length: 80mm f/2.8 Planar T* CFE;
ISO: 200; *Aperture:* f/2.8;
Shutter Speed: unrecorded;
Lighting Notes: The lighting for this image is entirely from natural light on a sunny afternoon in the spring or summer.

photo © Andrew Darlow

Tip #7

Use Shutter Priority Mode to Control Your Shutter Speed

18

Shutter priority mode is another powerful shooting mode. It allows you to keep the shutter speed at one specific value, and as you change the shutter speed, the aperture will adjust automatically based on what the meter reads in the scene. The symbol for it is usually S or Tv, depending on the camera model. The advantage of this mode is that it can help you keep your images sharp, which is important when photographing active pets, children, and others. Try setting the shutter speed to between $\frac{1}{125}$ sec and $\frac{1}{500}$ sec to begin. If you choose too fast a shutter speed, and if your camera can't set the aperture wide enough to expose the scene properly, everything will be too dark. In that case, add light, increase the ISO, or lower the shutter speed until your photo is properly exposed.

Another good use for shutter priority mode is when you are doing "tracking" or following the action of a person and/or pet. This is a great effect that makes the subject look as though he or she is running at supersonic speed. To use the tracking technique, set your camera to shutter priority and about $\frac{1}{2}$ sec to begin. Then pan and follow the motion of a walking or running pet (maybe during a brisk walk) as you depress the shutter button [w1.19]. Tip 8 covers some of the exposure focus options that can be helpful when using this technique.

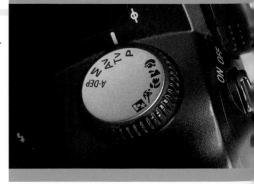

The dial on this Canon DSLR is set to Shutter Priority mode (Tv).
Other popular modes, such as Manual (M) and Aperture Priority (Av) can also be seen on the dial. A few "Basic Zone Modes," as Canon calls them, are also available, including Portrait, Landscape, and Sports mode. Other cameras have very similar options, but they are often selected and displayed on an LCD screen instead of a dial.
photo © Andrew Darlow

Tip #8

Take Control of Your Exposure and Focus Options

Setting and controlling your exposure and focus options are impor-
tant if you want to get the most from your camera. If you plan to
use manual focus or autofocus on your DSLR or point-and-shoot
camera, the main modes to choose between are single shot or
continuous shooting. Single shot will allow you take one photo at
a time, and you'll need to take your finger off the shutter release
and depress it again to take another picture. Continuous shooting
(called "burst mode" on some cameras) will allow you to take
multiple photos without taking your finger off the shutter release
until you fill your camera's buffer [w1.20].

Another autofocus option found primarily on DSLRs (when in auto-
focus mode) is AI Servo AF. This mode allows you to track a moving
subject, like a running dog about to leap to catch a Frisbee or
other flying object. Follow the dog by pressing the shutter button
halfway until you are ready to take the shot (or multiple shots). AI
Servo AF mode will keep changing the focus point for you until
you take your finger off the shutter release [w1.21].

Exposure compensation and Auto-exposure bracketing are two
very useful controls found on most DSLRs and many point-and-
shoot cameras. Like some of the more complex topics presented
throughout the book, I've written a detailed article about both
features on the companion Web site [w1.22]. Exposure compensa-
tion is also covered in Chapter 3, Tip 28.

The photo on the next page of a client's Maltese relaxing on a
white bedspread is a "high key" or predominantly white picture
that required me to increase the exposure about +1.5 EV in order
to make a proper exposure. I used exposure compensation to
make the adjustment, and I could have used auto-exposure
bracketing

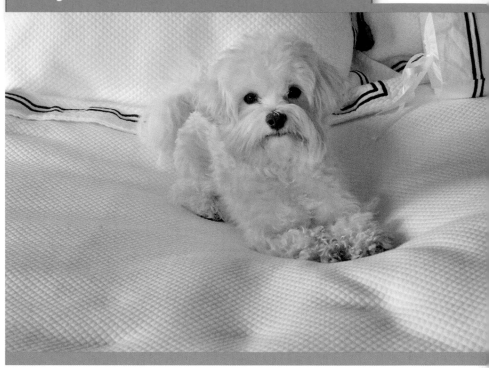

> "Take your time, I'm not going anywhere."

Camera: Nikon D1X;
Lens/Focal Length: Nikkor 50mm;
ISO: 200; *Aperture:* unrecorded;
Shutter Speed: $\frac{1}{30}$ sec;
Lighting Notes: The lighting for this image is coming almost entirely from natural light through the windows (camera left). A few lightbulbs in the bedroom add some warm light to the dog and bed.

photo © Andrew Darlow

Tip #9

Know Your Flash Options

There are many flash lighting options available for cameras, from using the built-in flash on a point-and-shoot, to multiple off-camera flashes with a DSLR. With a little research and experimentation, you can start making incredible photos of your pets and other family members using flash photography, and it can be done on virtually any budget. Creative lighting is covered in more detail in Chapter 8.

This photo of a woman with her Soft Coated Wheaten Terrier demonstrates how you can blend outdoor lighting with flash. The lighting is coming from the early evening setting sun, as well as an off-camera diffused flash (placed slightly camera right).

21

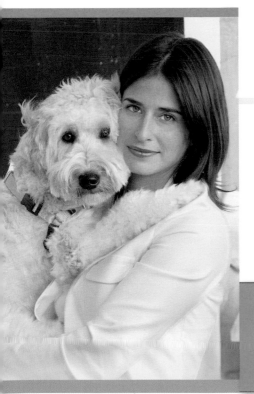

Camera: Canon EOS 20D;
Lens/Focal Length: Tamron 18–200mm Di II/149mm;
ISO: 400; *Aperture:* f/10;
Shutter Speed: $\frac{1}{400}$ sec.

photo © Andrew Darlow

"I think I can dig up an extra Hollywood ticket for you as well."

Tip #10

Determine a removable storage option, as well as the resolution settings for your needs

22

Removable digital media cards, such as CompactFlash cards and SD/SDHC cards, are a modern miracle. Unlike most commodities, their cost per gigabyte has dramatically fallen over the last 10 years. The read/write speeds of most cards have also been increased both with regard to image capture as well as download speeds. You can find some extensive speed tests online, as well as many user reports [w1.23].

The question of how many megapixels one needs is primarily up to the user. Some people will be perfectly content with a 2-megapixel camera phone, and others will require a 20+-megapixel DSLR to do what they want to do with their pictures. The best advice I can give is not to base your decision solely on megapixels. Some 5- or 6-megapixel cameras will produce far better images with less noise than 12-megapixel cameras at the same or similar camera settings. In general, to make a good-quality print up to 11 × 14 inches without much post processing, you should have at least a 6-megapixel point-and-shoot or DSLR camera with a good-quality lens.

It is also important to realize that you don't have to always shoot at the full resolution that your camera offers. If you know that the pictures you are taking never need to be larger than about 1000 × 1500 pixels (4.5 megapixels), you can choose a resolution close to that number, even if you have an 8–, 10–, 12–, or 14+-megapixel camera. Look in your camera's menu to make the adjustment. If you are shooting in JPEG, also note that there is usually a high-, medium-, and low-quality option available at different resolutions. Experiment to see the differences on a large screen, and be sure to check your resolution settings before starting a shooting session.

Some DSLRs even have RAW file capture options that are smaller than the full resolution of the sensor. For example, the 21-megapixel Canon EOS-5D Mark II offers not only a 21.1-megapixel RAW, but also a 10- and 5.2-megapixel RAW. This is a big advantage over just having smaller-sized JPEG options. [w1.24]

Tip #11

Learn Techniques for Capturing Action and Sports Photos

Getting great action shots of pets, whether they are running through the yard or at a competitive event, can be a challenge. Here are a few tips to get you started:

- The important thing to realize is that action shots don't have to be tack sharp. Blurs of all types can look great, so experiment with different shutter speeds (try shutter priority mode), as well as the tracking technique described in Tip 7.

- Shoot at a relatively high ISO level, but not so high that you will introduce unwanted noise.

- Use a long lens (from about 100–300mm in 35mm terms) if you want to take detail photos from a good distance, but don't forget to pack a wide-angle lens for the environment shots (for example, a dog or cat standing in the middle of a football field).

- Use a tripod or monopod to help increase stability with longer lenses.

- Try aperture priority mode to control depth of field. Generally you will set your aperture to the widest setting (for example, f/2.8 or f/4) to allow the maximum amount of light in for your lens.

Throwing a ball or other object that your dog likes to fetch (or having someone swing a toy from a stick to entice your cat) are great ways to practice this technique. Links to action photography articles can be found on the companion Web site [w1.25].

For the action-packed photo on the next page, I photographed a client's dog playing with her neighbor's dog in her yard in December at about 5 P.M. Both dogs had a favorite item in their mouths and I'm not sure where they were headed, but they were going there fast! Pictures like this are a lot of fun to make and share with friends and family.

23

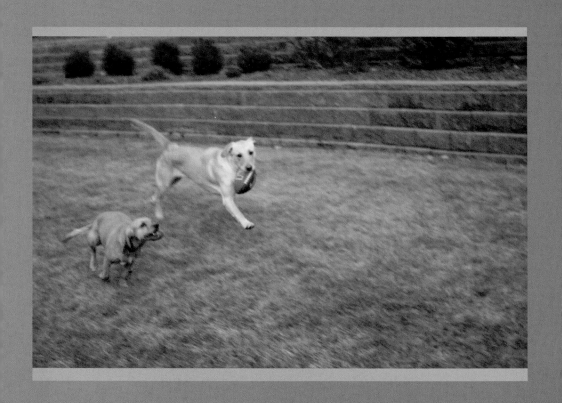

Tip #12

Find other appropriate learning resources, including photo groups, conferences, and books

There are many ways to learn about photography, from books to group workshops to individual training by a professional in the field. There are also many groups and organizations around the world that you can join. Some have monthly meetings with an average group of less than 20 people, and others conduct conferences in which thousands attend. To delve deeper into the art and science of photography, from capture techniques to asset management to retouching and printing, I've compiled a list of suggested groups, books and other resources on the companion Web site [w1.26].

25

"First one to get over there wins!"

Camera: Canon EOS-D60;
Lens/Focal Length:
Canon 16–35mm/35mm;
ISO: 400; Aperture: f/2.8;
Shutter Speed: $\frac{1}{125}$ sec;
Lighting Notes: Outdoor natural light provided all the lighting.
photo © Andrew Darlow

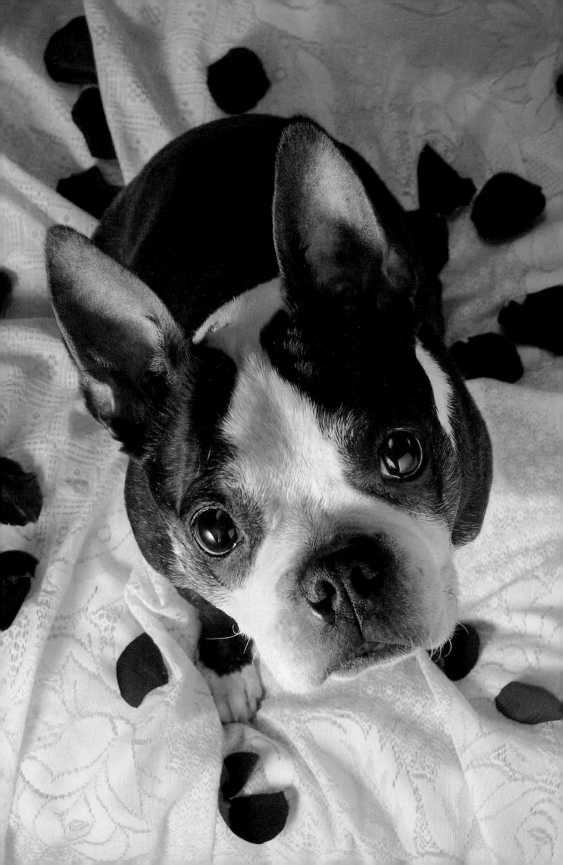

It's All about Perspective: Tips for Composition and Camera Placement

So often we see photos of pets (and kids) from an adult's perspective, which can be charming and beautiful, but at the same time, a bit predictable (dare I say, even a bit boring). In this chapter, I suggest some tips for mixing things up and making your photos look like you've been floating around a movie set with a million-dollar camera rig.

Please note: When you see notations like [w2.1], it means that a related Web link (and usually additional information) can be found by visiting the book's companion Web site at *www.PhotoPetTips.com*.

Photo on facing page © Andrew Darlow [see Tip 16 for image information]

Tip #13

Photograph Your Pet Straight On, Eye to Eye

28

You can get great photos of your dog or cat (or a group of pets) by sitting on a low chair or staircase step, and looking directly into their eyes, or by having them sit on a chair or table to raise them up to a level that allows you to take their photo straight on without having to crawl around on the floor. It also helps to have someone else entice your pets from behind the camera with toys or noise-makers, or by calling their name.

I photographed this kitten at a client's home playing on her scratching post. The height of the post made it easy to capture this image eye-to-eye without crawling on the ground.

Camera: Canon EOS-D60;
Lens/Focal Length: Canon 50mm macro;
ISO: 200; *Aperture:* f/2.5;
Shutter Speed: 1/30 sec;
Lighting Notes: Natural daylight plus room light from some halogen lightbulbs provided the lighting.
photo © Andrew Darlow

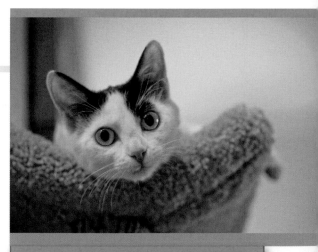

"First one who blinks buys the catnip!"

Tip #14

Lower Your Perspective and Make Your Subject a Hero

To create what is known as a "hero shot" (so named because it often makes the subject look more majestic), all you need to do is lower your perspective so that you are a bit lower than the pet's eye level (how low will depend on the pet, and experimentation is key). Like in the previous tip, toys and noisemakers work well to help create different poses.

29

In this photo of a Weimaraner, photographed in a park on a partly cloudy day at about 1 P.M. in late December, his owner was right next to him when I took the shot. I cropped it to a square because I liked that look much more in this case. That's a bonus tip that will be covered again in Tip 20 and other places throughout the book—use cropping to your advantage!

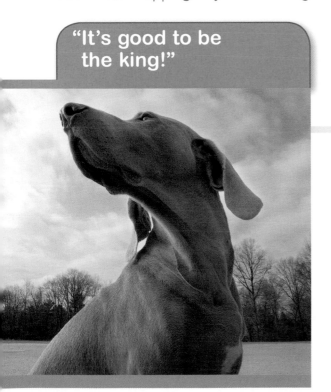

"It's good to be the king!"

Camera: Canon EOS-D60; *Lens/Focal Length:* Canon 16–35mm/16mm; *ISO:* 400; *Aperture:* f/19; *Shutter Speed:* $\frac{1}{125}$ sec; *Lighting Notes:* Natural daylight plus fill light from the built-in pop-up flash produced the lighting.

photo © Andrew Darlow

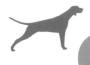

Tip #15

Photograph Your Dog or Cat from the Back

Many of my favorite photos are those captured from behind the subject. This perspective often gives a cinematic look that shows the viewer what the subject is seeing. You can work with this approach at many levels, from super wide to a macro view.

I captured this image of a cat and a few birds at a client's home on a sunny February afternoon at about 3 P.M. My goal was to have the viewer think about what the cat was thinking at the time. These types of photos can often tell a story, and they can be completely random or set up like in a movie. The f/2.8 aperture helped to keep the focus on the main characters in the image.

Camera: Canon EOS-D60;
Lens/Focal Length: Canon 16–35mm/16mm;
ISO: 400; *Aperture:* f/2.8;
Shutter Speed: $\frac{1}{350}$ sec;
Lighting Notes: Natural daylight from the windows provided the lighting, and some additional "fill light" was added on the cat in Adobe Photoshop.
photo © Andrew Darlow

"Birdies are friends, not food!"

Tip #16

Go for the Overhead View

By photographing your pet from a slightly more overhead angle than normal (or totally overhead), you can create some really dramatic looks. Like in the previous tip, this approach can work at many levels, from super wide to a macro view.

I photographed this Boston Terrier named Cupid at about 1 P.M. in December for a magazine's February issue (you can probably guess which holiday it was for). I photographed her from a number of different angles, but this overhead view was chosen for the magazine. The rose petals and soft material (it's a tablecloth) complemented Cupid and her big brown eyes perfectly!

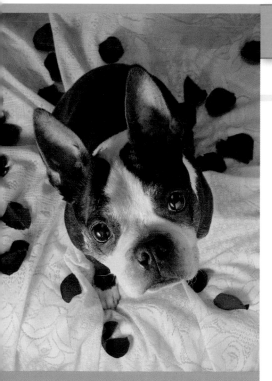

"Don't hate me because I'm huggable."

Camera: Canon EOS-D60;
Lens/Focal Length: Canon 28–135mm IS/28mm;
ISO: 200; *Aperture:* f/8;
Shutter Speed: $\frac{1}{20}$ sec;
Lighting Notes: Multiple incandescent lightbulbs were placed camera left with a large sheet of diffusion material [w2.1] in front of them to create the soft lighting and the big catch lights in the dog's eyes. Large sheets of heavy white paper (fill cards) surrounded the subject to soften the shadows. Some daylight from windows (camera left) added to the overall lighting.

photo © Andrew Darlow

Tip #17

Shoot from the Hip!

A walk through a city or town with a friend or family member is a great time to take photos of your dog. Fast shutter speeds and higher ISOs are key here unless you are after creative blur or motion blur. Don't worry if you don't get everyone's head in the picture. As long as the four-legged subjects get proper coverage, everyone will be happy!

This shot was taken on the way to a park along the Hudson River in New York City at about 7 P.M. in June. I love how animated pets can be. It may take a lot of shutter clicks to get pictures you are really happy with, so keep on shooting!

Camera: Canon EOS-20D;
Lens/Focal Length: Tamron 18–200mm Di II/18mm;
ISO: 200; *Aperture:* f/5.6;
Shutter speed: $\frac{1}{1600}$ sec;
Lighting Notes: Natural daylight provided most of the lighting, and the light-gray pavement offered some nice fill light.

photo © Andrew Darlow

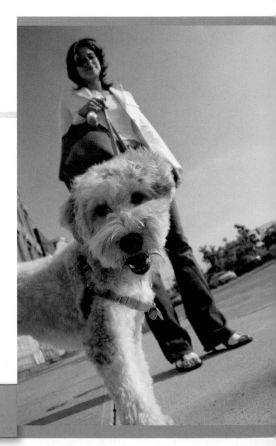

"I love New York!"

Tip #18

Use Technology to Get the Shot from Unusual Angles

There are only a few digital cameras that allow you to see what you're about to shoot without having to look through a viewfinder or at the LCD's "live view." Live view is a video representation of what your photos will look like before you take a shot. One way to expand your options is by using a flip-out viewfinder, which can be found on a growing number of DSLRs and point-and-shoot digital cameras. Another option is from Zigview [w2.2]. The product is a digital angle finder that attaches to many SLR cameras that have live view and video out. Also available is an inexpensive and ingenious mirror attachment called the Flipbac [w2.3]. It provides a way to hold your camera at a low angle while viewing a reflection of the live image on the mirror. It also doubles as a screen protector. And don't forget video cameras. Many have flip-out screens and good-quality still-image capture modes.

33

Any camera with a live-view option can help expand your creative options by allowing you to hold the camera at different angles, such as directly over your pet. Or be adventurous by just setting the camera to autofocus (or use the distance scale on your camera or lens), then shoot by pressing the shutter button manually, via self-timer, or from a remote shutter release, and check the results on the LCD screen. Isn't technology wonderful?

The Flipbac Angle Viewfinder in the closed and open position.

photo courtesy Flipback Innovations

Tip #19
Go for the "Snail's Eye View"

34

By getting low on the ground and shooting up toward your subjects, you can create some really dramatic imagery. If you are outside, it's a good idea to bring along some plastic bags to kneel or lie on while taking these types of pictures (one-gallon resealable bags work well). Just roll up a few and pack them away for when you need them. You can also find foam kneepads at most home improvement stores (look in the carpet or painting section)—they are good if you will be standing, then kneeling, because they usually attach via a recloseable fastener. For real die-hards, heavy-duty skateboard kneepads are another option.

I took this photo of a friend's bulldog at a park from a very low viewpoint just after noon in early September. I really like how the foreground becomes an important part of the overall picture. It's a good idea to experiment by including different amounts of foreground in your photos when shooting close to ground level.

Camera: Canon EOS-D60;
Lens/Focal Length: Canon 28–135mm/28mm;
ISO: 200; *Aperture:* f/3.5;
Shutter Speed: $\frac{1}{4000}$ sec;
Lighting Notes: Natural daylight on a clear day at about noon was the only light used. A fill flash can also be used effectively in this situation.
photo © Andrew Darlow

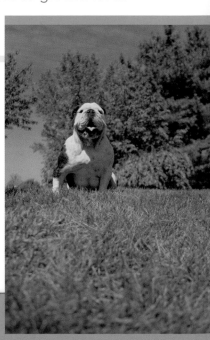

"I proclaim this land: Bulldogsville!"

Tip #20

Photograph Your Pet in Your Home Using a Wide-Angle View

Time does not stand still, but if you can get your dog or cat to stand still for a moment, you can photograph them in time, and have memories of the places that are important to you. Follow them around the house to capture multiple locations. Wide-angle views using cameras with wide-angle lenses help to fit more in a scene, but try not to make your photos too "busy." It's great to see how your pet, other family members, and even furnishings change over time. Another way to get a wide-angle feel is to crop a photo so that it looks like a panoramic image (either horizontal or vertical).

This photo opportunity presented itself to me when a client's kitten decided to stroll across her couch at about 5:30 P.M. on a sunny March afternoon. I particularly like the additional cat in the photo, which leads me to another tip: Include real and not-so-real pets in your photos for an added twist!

35

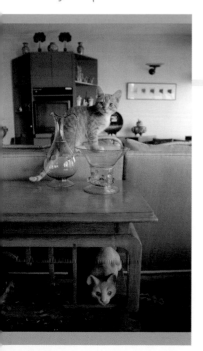

 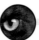

Camera: Canon EOS-D60;
Lens/Focal Length: Canon 16–35mm/16mm;
ISO: 200; *Aperture:* f/2.8;
Shutter Speed: $\frac{1}{45}$ sec;
Lighting Notes: Natural daylight from a large window (camera right) and inside lighting from household lightbulbs combined to produce the lighting.
photo © Andrew Darlow

Tip #21

Use a tripod or similar device to stay sharp and extend your creative options

36

A tripod or other device that holds your camera can do wonders in many situations. One approach is to set up a scene, set a self-timer, and run into the scene to capture yourself with your furry friends (instant modern photo booth!). Other devices are available that allow you to attach a camera and extend it to allow for interesting camera angles, or to take a photo of you and your loved ones. Two companies that make such products are the X-Pod [w2.3] and QuikPod [w2.4].

In this photo of a woman and her Soft Coated Wheaten Terrier, photographed at about 10 P.M. in June on a rooftop in New York City, I placed my camera on a tripod to help ensure sharpness, as well as a level horizon line.

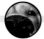 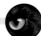 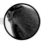

"Next time, I get to wear the green dress!"

Camera: Canon EOS-20D;
Lens/Focal Length: Tamron 18–200mm Di II/18mm;
ISO: 400; *Aperture:* f/6.3;
Shutter Speed: $\frac{1}{40}$ sec;
Lighting Notes: An off-camera flash placed on a stand (camera left) provided dramatic light on the model and her dog, and the slow exposure ($\frac{1}{40}$ sec) allowed for some of the city lights and sky to be recorded.
photo © Andrew Darlow

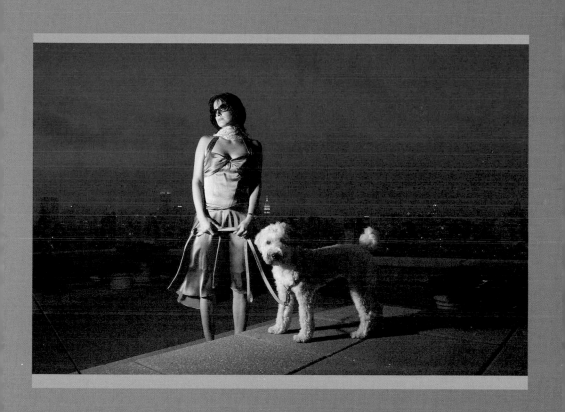

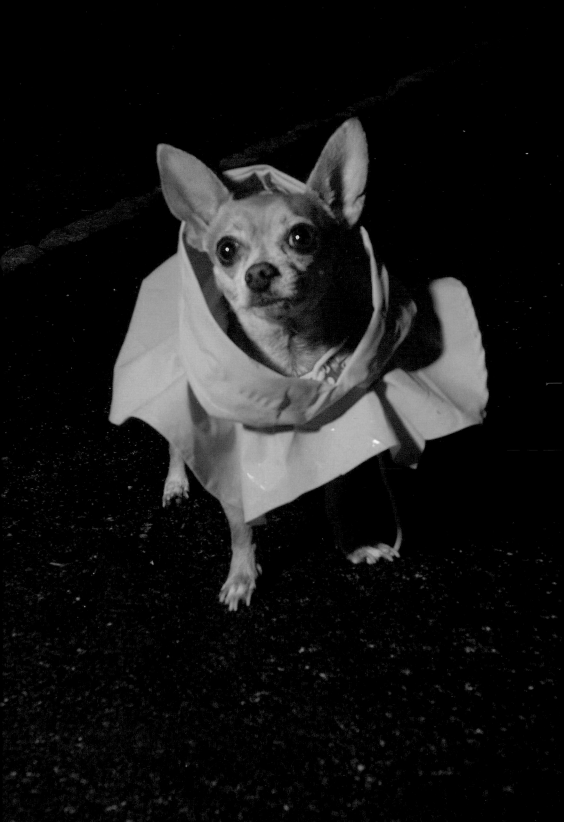

Bask in the Sunshine (or Rain!): Outdoor Lighting Tips

Ahh, the great outdoors. Rain or shine, winter, spring, summer, or fall, opportunities are everywhere for taking great photos of your pets and their people friends. Since most house cats stay in the house, these tips for getting better outside photos in any type of weather will feature dogs, but the same concepts can apply to cats, other pets, and of course, people.

Please note: When you see notations like [w3.1], it means that a related Web link (and usually additional information) can be found by visiting the book's companion Web site at *www.PhotoPetTips.com.*

Tip #22
Shoot Early or Late in the Day for More Dramatic Light

40

Someone named the time period just before sunrise and just after sunset the "golden hour" (also known as the "magic hour"), and it was for good reason. The light that one finds in most areas is lovely at those times, and the nice light usually continues for a few hours after sunrise and before sunset. The color temperature at those times is generally warmer than at midday, which produces a warm tone when your camera is set to daylight white balance mode. Also, at those times, the sun's rays tend to produce a softer light, and the sun casts longer shadows since it is not as high in the sky. There is also much less of a chance of getting "raccoon eyes," which can occur when the sun is high in the sky because of the way the shadows fall just under the eyes.

This photo of Elwood and his "mom" Karen was taken on a "mostly clear" day just after 4 P.M. in May. Notice how the setting sun (camera right) produces very nice light on Karen's jeans. And because of where Elwood is standing, just enough light is coming through to Elwood's face and body to create a very dramatic effect.

Camera: **Canon EOS-5D;**
Lens/Focal Length: **Canon 50mm macro;**
ISO: **640;** *Aperture:* **f/11;**
Shutter Speed: **$\frac{1}{400}$ sec.**

photo © Andrew Darlow

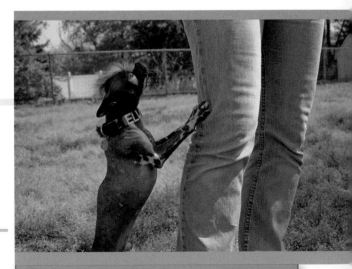

"I seem to recall the promise of a treat."

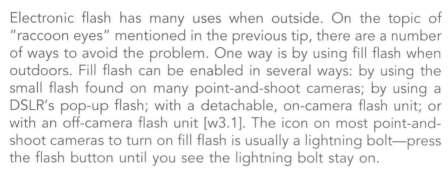

Tip #23

For Better Portraits, Use Flash When Shooting Outdoors

Electronic flash has many uses when outside. On the topic of "raccoon eyes" mentioned in the previous tip, there are a number of ways to avoid the problem. One way is by using fill flash when outdoors. Fill flash can be enabled in several ways: by using the small flash found on many point-and-shoot cameras; by using a DSLR's pop-up flash; with a detachable, on-camera flash unit; or with an off-camera flash unit [w3.1]. The icon on most point-and-shoot cameras to turn on fill flash is usually a lightning bolt—press the flash button until you see the lightning bolt stay on.

A removable flash unit that sits in your camera's hot shoe, or an off-camera flash are best for fill flash (or for flash in general when outside). That's because you can separate your camera lens from the flash, which reduces the chance of red-eye (or green-eye, as is the case with many pets), plus you can create larger catch lights in your subjects' eyes by using a diffuser over the flash, such as the LumiQuest BigBounce diffuser [w3.2]. An off-camera flash has the added benefit of allowing you to light from any angle. When using a DSLR with an external flash unit, fill flash can usually be controlled in a way that won't overpower the natural daylight (unless that's the look you're after). Check your manual to find out how to set fill flash properly.

I photographed this little girl and her Pug shown on the following page on a sunny day at about 1 P.M. in late August. An off-camera compact flash unit (Vivitar 285HV) was placed slightly camera right with a large diffuser about two feet (.6 meters) from the subjects. I asked the girl and her dog to stand under a tree to avoid most of the very bright areas you see in the background (some sun came through, but I think it adds to the overall look). I used manual mode on the flash and camera to find the right balance between the natural light and flash.

"That's right.... Do the Pug hug!"

Camera: Canon EOS-D60;
Lens/Focal Length: Canon 16–35mm/16mm;
ISO: 400; *Aperture:* f/9.5;
Shutter Speed: 1/90 sec.

Tip #24

Use reflectors when shooting outside, and use the sun like a lightbulb

Using one or more fill cards (often referred to as reflectors) can do wonders for your photographs. A fill card helps to direct light onto the subject. Reflectors can be white foam boards, white walls, posters, aluminum foil (for more dramatic effects) or anything else that helps to fill in or add drama to the main light. The sun shades often used to keep cars cool can be excellent fill cards, and some even fold up nicely into a small circle, like more expensive options from photo-related companies [w3.3].

43

If you think of the sun as a lightbulb, you can create many effects with natural light. Start by locating the sun in the sky. Then have your subjects turn slightly away from the sun, or find a place without direct sun so that the sun does not make them squint their eyes. Then use reflectors to direct light toward them. It helps to have an assistant hold the reflectors, and always be careful outside when using any type of stands, tripods, etc. (especially when they have a reflector attached), because they can easily get blown over by the wind. Sand bags or backpacks can be used on the legs of tripods or light stands to keep things more stable.

The light stand model shown on the following page is a Bogen 3361. It is lightweight and very strong. Attached to the top of the stand and circled in red is an Impact Telescopic Collapsible Reflector Holder. It has two strong clamps, and it is holding a collapsed and open version of an inexpensive 25 × 28-inch (63.5 × 71-cm) car windshield sun protector called the Axius Basix Magic Shade. Notice how one side is shiny silver and the other side is matte. The shiny side will produce a more focused, intense light (similar to aluminum foil), and the matte side will reflect light more softly. It should be noted that the Impact Collapsible Reflector also comes with a swiveling stand adapter (not shown). Circled in blue is a small Bosh 12-inch (30-cm) diameter translucent circular reflector. It folds up into a small circle and comes with a black protective zipper case (also shown in the photo). A number of companies make similar reflectors.

Circled in green is a Manfrotto Camera/Umbrella Bracket 143BKT, which is supporting the reflector holder. One way to use the camera/umbrella bracket is to attach a small flash unit to the 1/4-20 standard thread shown in the photo using a hot shoe mount like the Stroboframe Shoe – General Purpose. At the bottom of the frame is a gold sunshield, which can be found at auto-supply stores or online.

In addition to being used to reflect light, the translucent reflectors like the one circled in blue can be used to shoot light through (either sunlight or flash) to produce catch lights and beautiful soft light. More reflectors, as well as links to all companies mentioned, can be found on the companion Web site [w3.4].

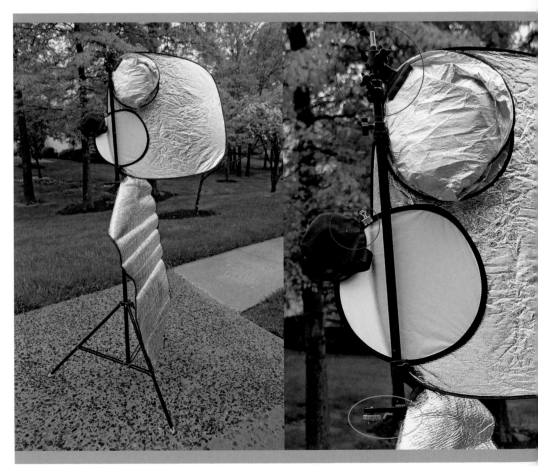

Tip #25

Let It Rain in Your Photos, but Not on Your Camera!

Rain can put a damper on one's day, but it can also offer many great photo opportunities. As long as your camera and lens stay dry, you will probably soon discover why images of your pets and other loved ones taken in the rain (or just after it rains) can be so rewarding. A resealable plastic bag can help keep your camera dry (just cut a hole for the lens), and if you are so lucky, a large umbrella held over you and your gear by a friend or family member can make a huge difference. Some go as far as using an underwater housing device to keep their gear dry [w3.5]. A soft, clean cloth for your lens, or even better, a package of photo wipes such as Pec-Pads [w3.6], stored in a small plastic bag can be invaluable for keeping your lenses clean and dry.

45

I took this photo of a little Chihuahua named Rosco one evening at about 11 P.M. in June for the *AKC Gazette*'s "Dog Day America Special Issue." It had been a long, rainy day, and the pavement was an ideal background for him to strike a pose in his uber-chic yellow raincoat.

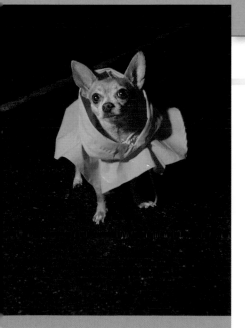

"I'm too sexy for my coat!"

Camera: Canon EOS-D60;
Lens/Focal Length: Canon 16–35mm/16mm;
ISO: 400; *Aperture:* f/8;
Shutter Speed: ⅙ sec;
Lighting Notes: An off-camera flash (camera left) about 10 feet from the dog provided most of the lighting, but the relatively slow shutter speed allowed some of the ambient street lights and house lights to play a part in the overall look of the image.

photo © Andrew Darlow

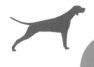

Tip #26

Might as well ... JUMP! Capture Airborne Action Outdoors

46

Photos of jumping dogs and cats offer a great opportunity to practice your reflexes, and capturing those moments in time can result in some truly amazing images. Some ideas for getting pets to jump include throwing a Frisbee or similar toy, holding a treat or toy up high, or by just saying "Jump!" On a more technical note, the best way to freeze action is by using fast shutter speeds ($\frac{1}{1000}$ sec or faster) and a steady hand (or tripod). That being said, some blur can be interesting, so experiment a bit until you get something you like. It may take some time to get photos you are happy with, but it will be worth the effort. Also consider using your camera's continuous exposure (burst) mode. Many cameras can shoot between three and eight frames per second. [w3.7]

I photographed this jumping Chinese Crested outside on a February afternoon at about 4 P.M. Lower vantage points like this help to add to the drama. You can also experiment with including or not including the ground in your photos, either when shooting or when cropping.

Camera: Canon EOS-5D Mark II;
Lens/Focal Length: Canon
28–135mm/85mm;
ISO: 640; *Aperture:* f/5.6;
Shutter Speed: $\frac{1}{2500}$ sec;
Lighting Notes: Natural daylight
(camera right) was the only light
used.

photo©Andrew Darlow

"Three ... two ... one ... blastoff!"

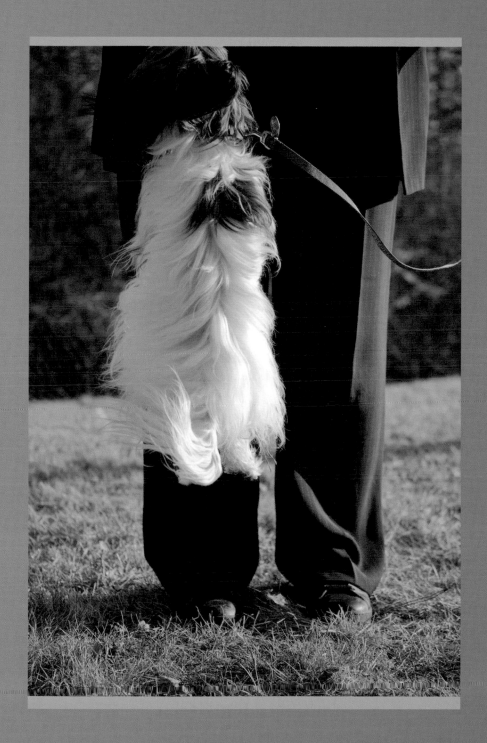

Tip #27

Use the Power of Scale When Outdoors

The great outdoors offer us an incredible array of trees, mountains, and man-made objects in which to frame our pets and other family members. Like Tip 20 in Chapter 2 about including parts of your home when photographing a pet, when you're outside you can also include parts of your house, backyard, or other surroundings.

This photo was taken during an assignment at a client's home at about 3 P.M. on a September afternoon. I let the pets roam around and captured this image of her Rhodesian Ridgeback enjoying a glorious day in her backyard near some majestic trees. Today's high-quality zoom lenses make it easier to shoot at a number of different zoom levels, whether the lens is built into your camera or removable.

> "I'm so relaxed, I might just have to recite a haiku!"

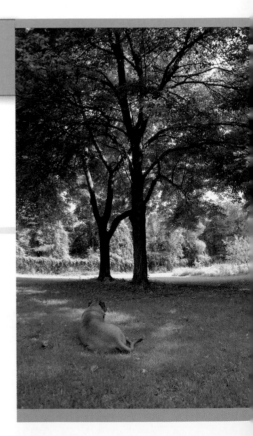

Camera: Canon EOS-D60;
Lens/Focal Length: Canon 16–35mm/16mm;
ISO: 200; *Aperture:* f/3.5;
Shutter Speed: ½₂₀₀ sec;
Lighting Notes: Natural daylight provided most of the lighting, and the trees helped provide the dappled lighting effect.
photo © Andrew Darlow

Tip #28

Let It Snow, Then Capture Your Pets In and Around It!

Snow can be incredibly beautiful, but all too often we keep our cameras inside when we're outside in the snow with our pets and other family and friends. Some snowy photo ideas include: close-ups of a dog's whiskers covered with tiny icicles; photos of a family wearing the same style of sweater as their lap dog; and a dog and a child on a sled with snow-covered mountains in the background. Most camera meters treat everything as if it is medium gray, so if your camera has the capability, set the exposure compensation to about +1 or +1.5 EV when outside in the snow for better overall exposures [w3.8]. If your camera has a highlight alert feature that makes the blown-out areas blink on your LCD screen, enabling it can help to let you know when the snow or sky is overexposed [w3.9]. Also, shooting in RAW mode (instead of JPEG) can help to retain detail in these cases.

I photographed the lovely Soft Coated Wheaten Terrier on the following page at about 2 P.M. one afternoon a few days after a big February snowfall. I kept shooting as I zoomed in and out with my lens and my feet. I made sure that my exposure was okay, but I didn't worry too much about what the images looked like until we were both inside in a more comfortable temperature. When time is limited, it's better to get the shots and review them later. It also usually makes for some great surprises (much like when shooting with film cameras).

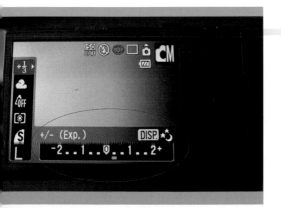

The Exposure Compensation adjustment area on a Canon point-and-shoot camera is circled in red.

photo © Andrew Darlow

"What was that again about the yellow snow?"

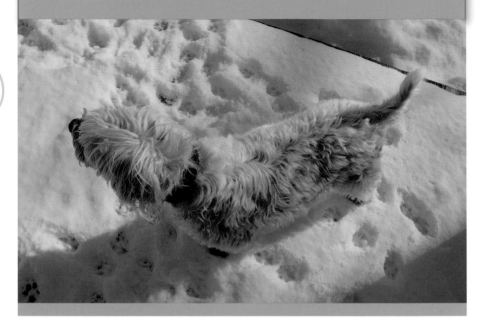

Camera: Canon EOS-5D Mark II;
Lens/Focal Length: Canon 28–135mm IS/28mm;
ISO: 200; *Aperture:* f/11;
Shutter Speed: $\frac{1}{640}$ sec;
Lighting Notes: Natural daylight on a clear day was the only light used. A fill flash or reflector can also be used effectively in this situation.

photo © Andrew Darlow

Tip #29
Use the Wind to Your Advantage

Whether Mother Nature provides it, or whether you create it in some way, our furry friends (and anyone with some hair or loose clothing) can appear as though they are flying, or just enjoying a day at the beach with help from wind. Wind effects can be created with an electric fan or from an open window while in a moving vehicle. Of course, always use caution when in any vehicle with pets, or when using any electrical devices. Pets can easily trip over just about any cord, and some fans can pose a risk if pets try to get their paws on them.

This "windy" photo of a Chinese Crested was taken in mid-winter on a very windy day. I shot the photo handheld, and held my camera as steady as I could. Autofocus mode, a fast shutter speed, and relatively high ISO helped ensure good sharpness in this image and most of the photos from the session.

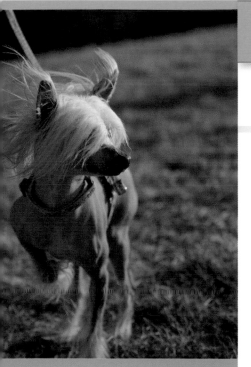

"Hey, who turned out the lights?"

Camera: Canon EOS-5D Mark II;
Lens/Focal Length: Canon 28–135mm IS/28mm;
ISO: 640; *Aperture:* f/5.6;
Shutter Speed: $\frac{1}{2500}$ sec;
Lighting Notes: Natural daylight (camera right) provided all of the lighting.

photo © Andrew Darlow

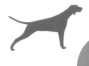

Tip #30

No Sun, No Problem! Use Cloudy Days to Their Full Extent

You may think that a bright, sunny day with a clear, blue sky offers the best lighting for outdoor photos. It's true that clear, blue skies can look great (especially early and late in the day), but cloudy days offer softer, more diffused lighting that can be very flattering to your subjects. Even on cloudy days the sun will usually produce directional light that creates soft shadows, so use the same basic techniques described in earlier tips in this chapter. And of course, there are all kinds of "mostly cloudy" or "partly sunny" days, which provide for an ever-changing palette of light and shadows.

This photo was taken in a wooded area near a client's home in mid-December at about 5 P.M. Although it was cloudy, the sun (camera left) was just about ready to set, and it created a slightly warm, soft, and directional feel.

Camera: Canon EOS-D60;
Lens/Focal Length: Canon 16–35mm/35mm;
ISO: 400; *Aperture:* f/2.8;
Shutter Speed: $\frac{1}{180}$ sec.

photo © Andrew Darlow

"This is exactly how my 'Dog of the Year' statue should look."

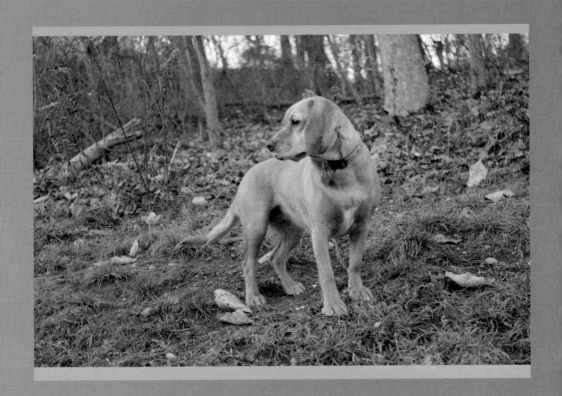

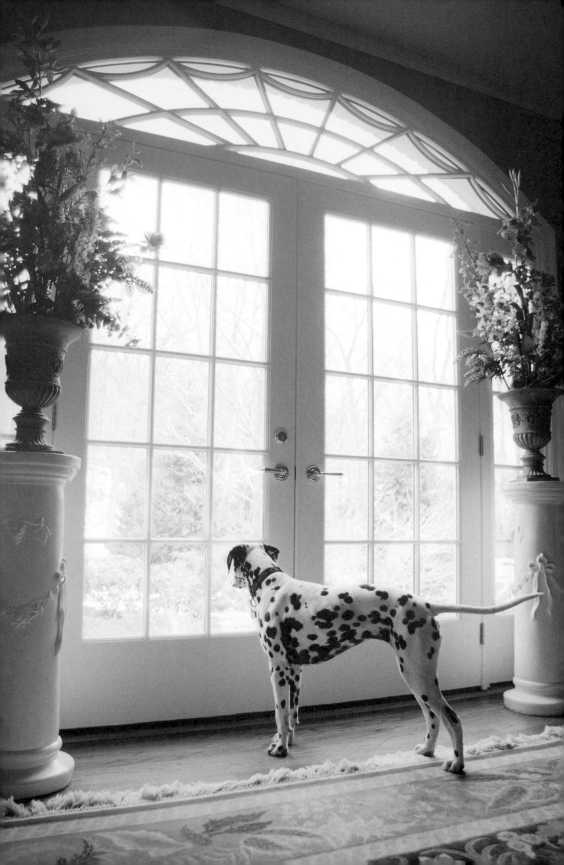

I Do Windows!—
Window Lighting
Tips

Windows can be found just about everywhere, and with some
help from the sun they can produce a beautiful quality of light
that can be used in many different ways. Another bonus to
window lighting is that pets often love to sit on window sills or
near windows, which can make for many impromptu "photo
ops." Following are some tips to help you use window lighting
effectively to make better photos. Many of the tips can be
applied to other situations as well, such as when you are shoot-
ing with electronic flash, or even when you are outside.

Please note: When you see notations like [w4.1], it means that a related Web link (and
usually additional information) can be found by visiting the book's companion Web site
at *www.PhotoPetTips.com*.

Tip #31

Use Modifiers to Control Window Light Effectively

Windows with no shades or drapes can transmit light very nicely, but there are many ways to use window hangings to expand the creative possibilities. For example, if you have Venetian blinds or vertical blinds, beautiful dappled light can be produced very easily. Look closely at your pet and other family members to see how the light changes as you make adjustments to the blinds [w4.1]. Depending on the weather, time of day, and time of year, the intensity, color, and overall look of the light will also change.

Translucent fabrics are often used to filter window light, which can help make the light very soft, elegant, and flattering to both people and pets. If you don't have any window coverings, there are other diffusion materials that can be used, including tracing paper, sheets of white paper, shower curtains, bed sheets, or milk acrylic (often called "milk Plexi") [w4.2]. Venetian blinds can be purchased inexpensively and are especially versatile; just attach them to a light stand, place them in front of your windows, and you're ready to go.

I photographed this image of a client's cat in New York City in late January on a sunny day at about 5 P.M. The lighting came entirely from a bedroom window, and was modified by some fabric window hangings. The window hangings primarily helped to produce the shadow on the foreground, and they held back some of the light falling on the pillow in the background.

Camera: Canon EOS-D60;
Lens/Focal Length: Canon 28–135mm/47mm;
ISO: 200; *Aperture:* f/5.6;
Shutter Speed: ½₅₀ sec.

photo © Andrew Darlow

"It's funny 'cause it's true!"

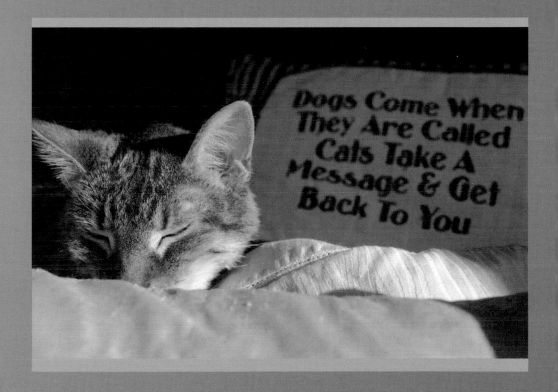

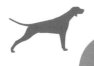

Tip #32

Shoot with a Window Directly Behind Your Subject to Create Silhouettes

58

Silhouettes in photos can be very captivating and dramatic. If your main light is coming from a window, and if that light is much brighter than the light falling on your subjects from the front, you can easily create a silhouetted image. Determining proper exposure can be a bit tricky, but most cameras set to automatic mode will result in a silhouetted image. Just be sure that your camera's flash doesn't go off.

For those who want more control, if you expose for the highlights and bracket plus and minus one stop, that should give you a good range of photos with which to work. Also, try not to blow out the highlights. You can always increase contrast later in an imaging program like Adobe Photoshop. Be aware that flare on your lens, which is usually caused by light falling on the front of your lens, can reduce contrast and produce unwanted light streaks (though it can also make for a nice effect). A lens hood (a.k.a. lens shade) can do wonders to reduce flare [w4.3].

I took this photo of a friend's Cockapoo on a mid-January day at about 1 P.M. The room was dark except for bright sunlight coming through a few windows. I used aperture priority mode and set the exposure compensation to +1 EV. Even after reducing exposure and using the recovery slider in Adobe Camera Raw, the highlights were still blown out in places, but I was very happy with the overall look of the lighting, as well as the glowing highlights on the dog's fur.

Camera: Canon EOS-D60;
Lens/Focal Length: Canon 16–35mm/16mm;
ISO: 400; *Aperture:* f/10;
Shutter Speed: ⅟₄₅ sec.
photo © Andrew Darlow

"Is this the talent portion of the show?"

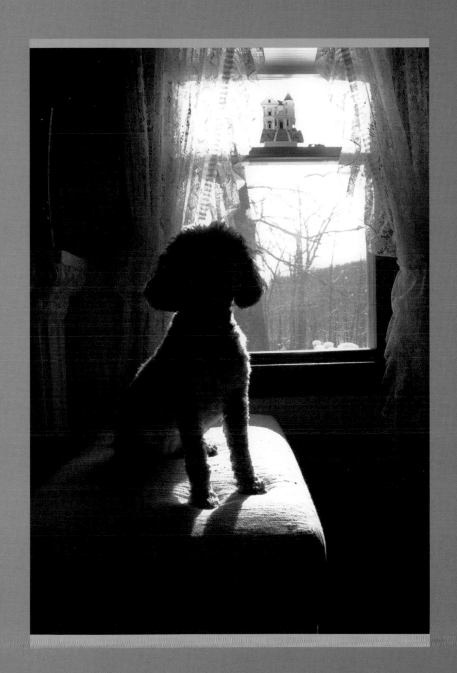

Tip #33

Fill Window-lit Silhouettes with Flash, Continuous Lighting or Reflectors

60

To follow up with Tip 32, a silhouetted image can be modified by adding fill flash, fill cards/reflectors, or continuous lighting (such as a handheld flashlight). For example, LED flashlights are bright, inexpensive, and very efficient [w4.4]. Just be careful not to use a light that is too bright for your subjects' eyes. To avoid that problem and to soften the light, a small piece of diffusion material (or even a napkin or piece of paper) over the light can help a lot. Products normally designed for flash units like the LumiQuest Big Bounce can also be used with LED flashlights [w4.5].

In this photo, taken a few minutes after the photo from Tip 32, my friend used a small LED flashlight with some diffusion over the light to add the catch lights and bring out detail in the dog's face and fur as I photographed her dog from different angles, positions, and focal lengths (from 16–35mm).

"Do I have anything in my teeth?"

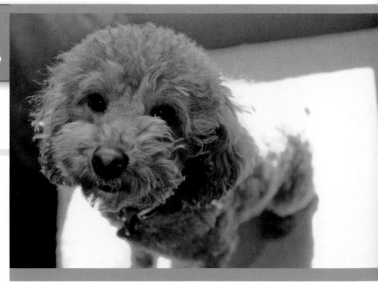

Camera: Canon EOS-D60;
Lens/Focal Length: Canon 16–35mm/35mm;
ISO: 400; *Aperture:* f/2.8;
Shutter Speed: $\frac{1}{250}$ sec.
photo © Andrew Darlow

Tip #34

Include a Large Window or French Doors for Some Dramatic Looks

Continuing the theme of including a window in your images, if you have a distinctive-looking picture window or French doors, try including them in your photos. If the light is not much brighter outside compared with inside, you can get a very nice overall look without losing detail on your subject.

61

For this photo of a client's Dalmatian, which I captured handheld at a beautiful home on a snowy day with a wide-angle lens, I just followed the dog around until she stopped to take a peek outside. I took at least 10 photos as she adjusted her tail here and there. Within just a few moments, she was on to her next adventure, which is common with pets, so it's important to be prepared and shoot a lot when the moment is right.

"Hurry, please! I see a squirrel who wants to play."

Camera: Minolta X-700;
Film: Kodak T400CN;
Lens/Focal Length: Minolta 50mm;
Aperture, Shutter Speed, and ISO: unrecorded.
Lighting Notes: Diffused, natural light from the sun provided much of the light, but the inside lighting from standard household bulbs and other windows helped to balance the exposure.

photo © Andrew Darlow

Tip #35

Zoom In and Use Windows Like Big Softboxes

One of the most visually interesting things about close-up portraits are the range of catch lights that you can capture in your subjects' eyes. Studio photographers often use umbrellas or softboxes with electronic flashes (usually made of a material with a diffused white fabric front) in a wide range of shapes and sizes [w4.6]. They not only produce a certain quality of light, they also produce catch lights in the eyes in a variety of sizes and shapes. Window lighting also offers this opportunity, and depending on how close you are to the window, and at what angle you photograph your subjects, you can produce some great effects. Interestingly, a related tip is to add black heat-resistant (and removable) tape to a softbox to simulate the look of a window. Just two pieces (about one inch wide) attached in a cross-like pattern over the face of the softbox can produce great effects.

I photographed this kitten in an apartment in New York City in mid-March at about 6 P.M. I moved in very close to her, and cropped even closer, which made one of the room's windows more clearly visible in her eyes.

Camera: Canon EOS-D60;
Lens/Focal Length: 50mm;
ISO: 200; *Aperture:* f/2.8;
Shutter Speed: $\frac{1}{180}$ sec;
Lighting Notes: Natural daylight provided most of the lighting, and a few lightbulbs in the room added to the overall look.

photo © Andrew Darlow

"This modeling thing is hard work!"

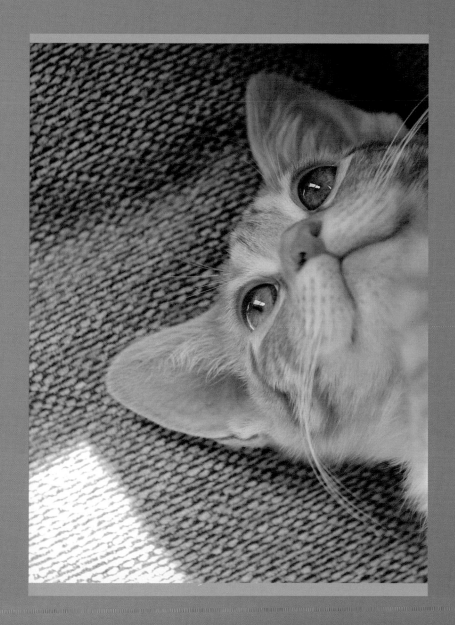

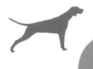

Tip #36

Photograph Your Loved Ones Relaxing in Bed or on a Sofa Lit by Window Light

64

One of the best times to photograph furry friends and other family members is while they are relaxing on a sofa, the floor, or a bed. That's a primary advantage you have compared with going to a photo studio to pose for a photo. The window light found in many bedrooms and living rooms is beautiful, and the standard suggestions for getting sharp photos in relatively low light pertain here (see Chapter 8 for more on low light). Also, it helps to let your people subjects know not to worry whether the dogs are looking toward the camera. It's important that people look at the camera so that they look great, but the photographer or an assistant should be the ones helping get the pets to cooperate. This is a tip you can use in many situations (especially with babies and young children).

For this photo of a client and her four dogs (three Maltese and a mixed breed), the sun was streaming through a nearly wall-sized window (camera left), and provided most of the light. Some warm lightbulbs in the bedroom provided the rest of the light, and added to the warm look and feel. I placed my camera on a tripod so that I could focus manually and get the framing I liked. It wasn't easy to get good expressions on all the dogs in just one photo, so I ended up borrowing from a few images and assembled them in Adobe Photoshop to get the results you see. That's a little secret covered in more detail in Chapter 9.

Camera: **Nikon D1X;**
Lens/Focal Length: **Nikkor 50mm;**
ISO: **200;** *Aperture:* **unrecorded;**
Shutter Speed: **$\frac{1}{10}$ sec.**

photo © Andrew Darlow

"We are fam-i-ly!"

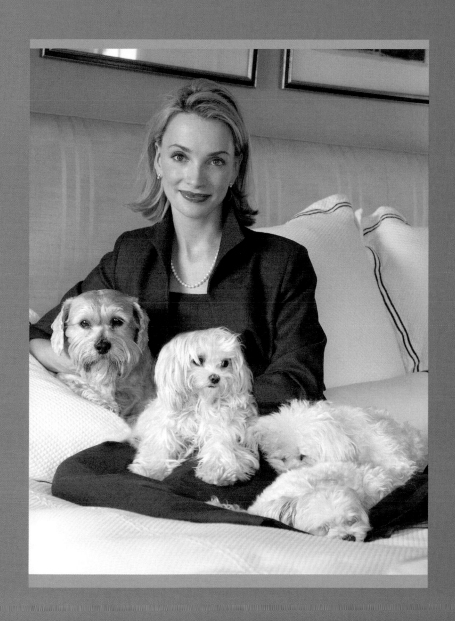

Tip #37

Shoot Through a Window or Glass Door from Inside or Outside

66

Windows and glass doors can be great for shooting through. For example, if you are outside your home looking in, you can photograph your cat or dog on a window sill or ledge near a window. Another option is to shoot from the inside with your pets outside. You can even spray some water on the window or door using an atomizer to create some interesting effects.

For this photo of a Basset Hound/Beagle mix photographed on a May afternoon around 3 P.M., I was inside and noticed the dog peering in. The hazy look that was being created by the sliding glass door and the light streaming through it combined for a great photo opportunity. After just a few exposures, the dog walked away.

Camera: Canon EOS-5D;
Lens/Focal Length: Canon 50mm;
ISO: 640; *Aperture:* f/3.5;
Shutter Speed: ⅟8000 sec;
Lighting Notes: Natural daylight provided most of the lighting, but light from inside the kitchen helped illuminate the dog's front side.
photo © Andrew Darlow

"Open, please! I've had enough exercise for this week."

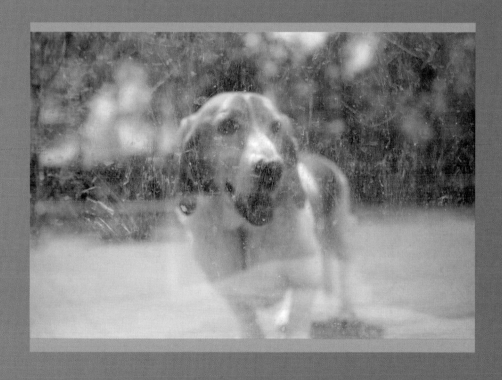

Let Sleeping Dogs (and Cats) ... Sleep

There are few sights more adorable than a resting or sleeping dog, cat, puppy, kitten, baby, or child (or a mix of them sharing time together)! In this chapter I suggest ways to photograph people and pets relaxing or sleeping, and I also offer ideas for lighting them effectively. And I promise not to be offended if you doze off while reading these particular tips!

Please note: When you see notations like [w5.1], it means that a related Web link (and usually additional information) can be found by visiting the book's companion Web site at *www.PhotoPetTips.com*.

Photo on facing page © Andrew Darlow [see Tip 40 for image information]

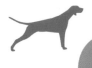

Tip #38

Get Low, Get Close, and Use Shallow Depth of Field

A low vantage point, shallow depth of field, and close-up framing like you see in this image are some of the techniques that can be combined to help make photos of resting or sleeping pets much more interesting. I photographed this sleeping kitten at about 6 P.M. in mid-March at a client's apartment in New York City. The low vantage point and shallow depth of field (f/3.5 aperture) caused the couch cushions in the foreground and background to be out of focus. The front cushion is particularly significant because it leads the viewer's eyes to the kitten's face without being distracting.

A tripod can help keep things sharper in these cases, and manual focus can also be helpful if you are trying to pinpoint a specific area, such as the kitten's nose. The 50mm macro lens I chose is ideal for these types of pictures, and it creates an effect equivalent to about a 75mm lens on a full-frame 35mm camera. See Chapter 1, Tip 3 for more on lenses and the multiplication factor.

Camera: Canon EOS-D60;
Lens/Focal Length: Canon 50mm macro;
ISO: 400; *Aperture:* f/3.5;
Shutter Speed: ½₀ sec;
Lighting Notes: Diffused, natural light from the sun through the room's windows (camera right) provided most of the light, and some household lightbulbs in the room added to the overall lighting.

photo © Andrew Darlow

"Beauty sleep in progress."

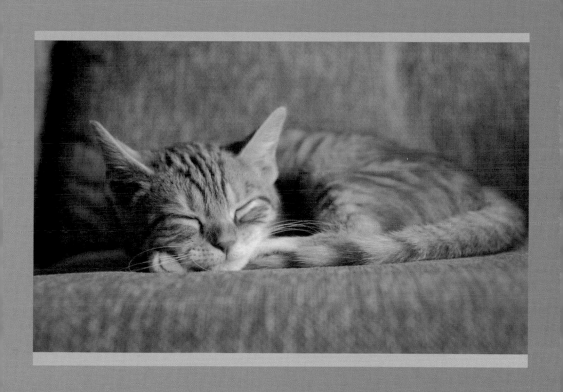

Tip #39

Share Your Chairs with Your Four-Legged Friends

A pet relaxing on a chair (with or without a few companions) can make for some great photos. It doesn't really matter from which angle you photograph your dog or cat sitting on a chair, but I especially like a straight on perspective, or from above. And if you have a few chairs, a few dogs, and a deck of cards, you can recreate a classic velvet painting!

For this photo of a client's Dalmatian, I photographed the dog relaxing after a long run with her owner. I like a focal length of about 20–30mm (in 35mm terms) for these types of angles and images, and a zoom lens helps allow for more experimentation. Another quick tip in a situation like this is to walk completely around the chair, shooting from about the same angle of view that you see in this picture. Then move the camera more overhead when you get to the back of the chair since it will otherwise block the shot.

Camera: Nikon N90;
Film: Fuji Sensia 200 Color Slide;
Lens/Focal Length: Sigma 28–105mm/ approximately 28mm;
Aperture, Shutter Speed, and ISO: unrecorded.
Lighting Notes: I used the available sunlight that was streaming in from large windows (primarily from the left), plus a few lightbulbs that were on in the home. The light on the chair is a bit blown out, but I like that look, because it makes the image feel as though it is full of warmth and light on a sunny day. The key is not to let it blow out too much (see Chapter 3, Tip 28, for more on that).
photo © Andrew Darlow

> "Was that a dream or did I hear the word LUNCH?"

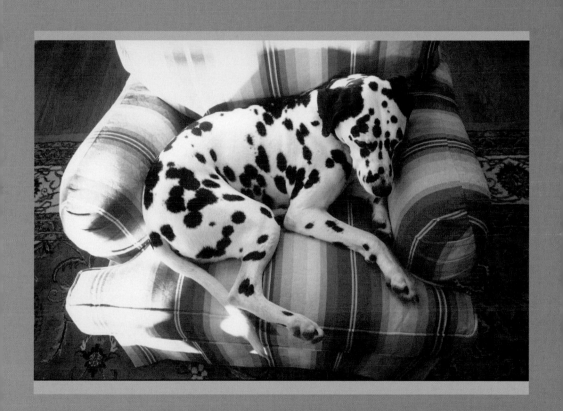

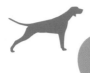

Tip #40

Look for Interesting Framing Opportunities Around the Home

In Chapter 4, window-related tips were discussed, including a tip about including windows as architectural details in your photos. There are many other features found in homes, such as attractive doorways, fireplaces, and staircases. Pets seem to often place themselves perfectly in these locations to take "cat naps," so you just need to look for opportunities and be there to capture the moments.

I photographed these two cats at a client's home in February at about 3 P.M., "guarding" the living quarters much like the stoic lions outside the New York Public Library on 5th Avenue. The wide-angle lens made all the difference here because of the way it helps to bring in so much of the surroundings. Because I used a zoom lens (16–35mm), I was able to get many different looks very quickly (including both vertical and horizontal shots). The cropped final version shown on the facing page, left side, is quite different from the uncropped version on the right.

Cropping is extremely important, and every photo can be altered dramatically with cropping, so experiment a bit. You may also notice that a little retouching was done to remove the bottoms of the frames that were at the top of the photo. I also removed the hinge from the door on the right. I don't normally do much retouching on my pet photos, but sometimes a little bit of work like this can improve an image dramatically.

Camera: Canon EOS-20D;
Lens/Focal Length: Canon 16–35mm/16mm;
ISO: 400; *Aperture:* f/2.8;
Shutter Speed: $\frac{1}{50}$ sec;
Lighting Notes: Natural daylight provided much of the lighting, but additional light from lightbulbs around the home and in spotlights just behind the cats helped add to the overall lighting.

photo © Andrew Darlow

"I think we slept through the changing of the guard!"

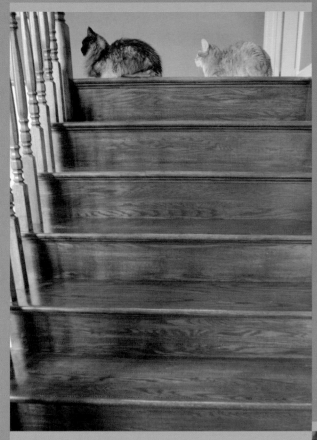

Tip #41
Photograph Your Subjects Stretching in Outrageous Ways

76

Dogs and cats often seem to defy the laws of physics with the ways in which they can stretch out and twist themselves up—often while sleeping. This black-and-white cat was very, very relaxed when I snapped this photo of her with my camera placed directly on the carpet for stability and to get the low vantage point. These kinds of moments happen all the time in many homes, so have your camera ready! The shallow depth of field (f/2.8) definitely helped to enhance the overall effect.

There are many things you can use when in a situation like this to help steady the camera when you are low on the ground. A folded towel or t-shirt can work well, and a thick mouse pad is another option because of the way it gives support [w5.1]. Beanbags of all types have been used for years, and you can make your own from a few resealable bags [w5.2]. There are also some interesting products made specifically for this purpose and similar purposes, including the POD [w5.3], Monsterpod [w5.4], Omnipod [w5.5], and Cam-Pod [w5.6].

Camera: Canon EOS-D60;
Lens/Focal Length: Canon 16–35mm/35mm;
ISO: 400; *Aperture:* f/2.8;
Shutter Speed: $\frac{1}{60}$ sec;
Lighting Notes: Lighting came primarily from a single off-camera diffused flash (camera left). Some natural light from a large window (also camera left) provided additional light, and some household lightbulbs added some of the warm light on the cat's paws, as well as the warm shadows.

photo © Andrew Darlow

> "Welcome to this week's episode of *Cat Nap Yoga.*"

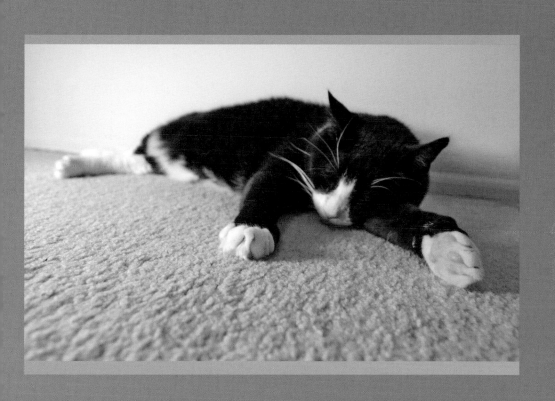

Tip #42

Get Some Bed Shots, and Vary Your Aperture

One of the best places to capture pets napping and in deep sleep is, of course, in bed. That could include a traditional pet's bed, a combined cat scratching post/bed, or like in so many homes, any bed that has humans sleeping in it! In Chapter 4, Tip 36, I included a photo of a woman sitting with her four dogs in bed, and two were sleeping, which I believe adds a lot of warmth and reality to the image.

For this image of a Chinese Crested/Chihuahua mix (left) and Chinese Crested (right), I was able to get a range of expressions and angles as they both drifted in and out of their doggy dreams (see Tip 43 next for another shot from the series). I shot this on a beautiful spring day in May at about 2 P.M. The 50mm focal length on a full-frame 35mm DSLR helped create the feeling that the front dog is very close. She was about 12 inches (30cm) from my lens. The f/3.5 aperture contributed to the out-of-focus background (shallow depth of field). By using aperture priority mode and changing your f-stop, you can alter the depth of field dramatically in just a few seconds. Chapter 1 has more information on using aperture and shutter priority modes with many types of cameras.

Camera: Canon EOS-5D;
Lens/Focal Length: Canon 50mm;
ISO: 640; *Aperture:* f/3.5;
Shutter Speed: ⅟₃₂₀₀ sec;
Lighting Notes: Natural daylight (camera left) from a large glass door provided most of the lighting, and some overhead light from inside the room helped provide some fill light.
photo © Andrew Darlow

"Please do not disturb ... unless of course you have treats."

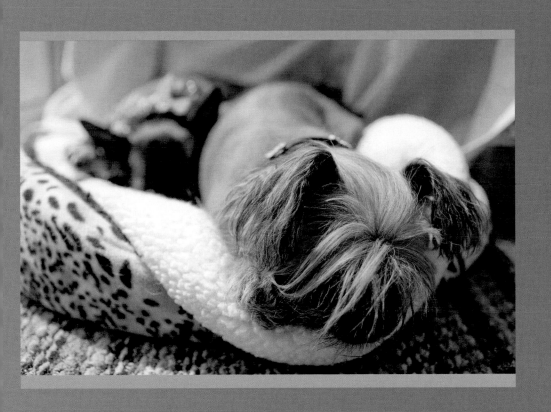

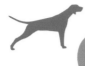

Tip #43
Capture One Pet Awake and One Asleep

When you have a few dogs or cats around, there are bound to be times when one is snoozing and the other is awake. This makes for a nice contrast between them, as in this photo of the same two dogs photographed in Tip 42. A related tip is to vary your aperture so that you can get more or less of the scene in focus. I prefocused on the left dog by half-pressing my shutter release, and then moved my camera to the right slightly to produce the framing and look you see. Manual focus could also have been used, which would avoid the need to recompose as I did.

Many point-and-shoot cameras have face detection that detects subjects and generally avoids the need to focus and recompose in these types of situations. That being said, I like to be in control of the focus points whenever possible. You really can't set up these types of special moments, but if you look for opportunities like these, you'll start seeing (and capturing) them more. Chapter 1 covers some more related tips and links about exposure.

Camera: Canon EOS-5D;
Lens/Focal Length: Canon 50mm;
ISO: 640; *Aperture:* f/4.5;
Shutter Speed: $\frac{1}{800}$ sec;
Lighting Notes: Natural daylight (camera left) from a large glass door provided most of the lighting, and some overhead light from inside the room helped provide some fill light.
photo © Andrew Darlow

> "May I go back to sleep now?"

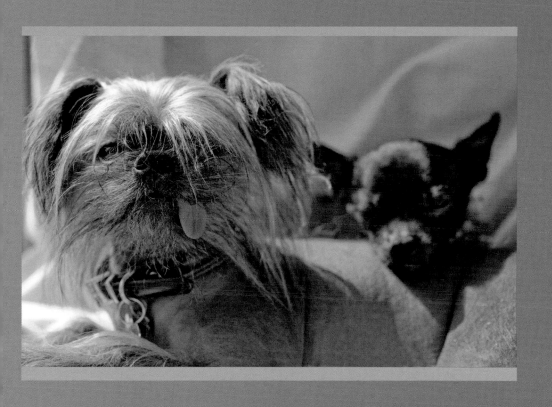

Tip #44

Photograph a Person Petting a Relaxed Dog or Cat

The act of petting a dog or cat has been shown in laboratory tests to reduce blood pressure, and I think we've all experienced the relaxing benefits that come with petting our furry friends. Although maybe not quite as potent, pictures of people petting dogs and cats can be quite relaxing as well, so consider taking some photos when your human loved ones share their affection with pets. Pictures taken from above when a dog or cat is in one's lap is one option, and another option is to shoot from a very low angle as someone pets the dog or cat on the head. You can also get a range of great expressions, such as tail wagging, purring or yawning, as you pet different areas. This can be hilarious at times—like when a dog shakes one of his legs in a funny way when being pet! For this photo of a Weimeraner, I captured him leaning in for some love from his owner. I took this photo shortly after the Hero shot of the same distinguished dog shown in Chapter 2, Tip 14. It is amazing how many different looks and emotions you can capture if you keep shooting!

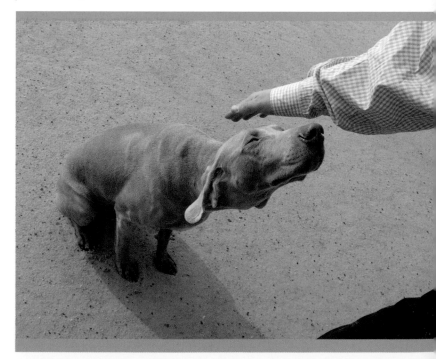

Tip #45

Gather the Troops on the Couch and Utilize the TV

As they say (or at least, as I say), the more couch potatoes, the merrier, and that certainly rings true for sleepy dogs and cats. Whether your pets find themselves on a big couch, love seat, or a chair that swings, when they get sleepy, photo opportunities soon appear. Feel free to invite your people friends as well to join in the fun.

Keeping the TV while shooting can help in a few ways. It can provide a good amount of light (especially in the evening in a darkened room), and depending on the size of the screen and the angle, it can help produce catch lights in your subjects' eyes. It can also serve as a common focal point to encourage the pets to look in the same direction—as long as everyone is interested in what's on!

In the photo on the following page, shot on the same day as the images in Tips 42 and 43, we politely asked some of the home's residents to join their "brother" Elwood (center) on the couch in front of the TV. It was just after 5 P.M. and it had been a long day for everyone, as you can tell from everyone's expressions. They all held in there nicely throughout the session. Some retouching was done, including reducing the redness in the front two dogs' eyes, adding some catch lights to the black dog's right eye, darkening the corners and top of the image, and increasing contrast on Elwood and the dog on the left. Many of these retouching tips will be discussed in Chapter 9.

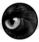

> "They don't call us Man's Best Friend for nothing."

Camera: Canon EOS-D60;
Lens/Focal Length: Canon 16–35mm/16mm;
ISO: 400; *Aperture:* f/9.5;
Shutter Speed: $\frac{1}{350}$ sec;
Lighting Notes: Natural daylight on a partly cloudy winter day was the only lighting.

photo © Andrew Darlow

"I'll flip ya to see who fetches the remote."

Camera: Canon EOS-5D;
Lens/Focal Length: Canon 50mm;
ISO: 800; *Aperture:* f/7.1;
Shutter Speed: $\frac{1}{100}$ sec;
Lighting Notes: Lighting came primarily from a single off-camera diffused flash, placed slightly camera right. Natural daylight from a few windows located on the right and left provided some fill light.

photo © Andrew Darlow

Tip #46

Don't Worry About Looking Perfect. Take Pictures of "Real Life"

I saved this tip for last in this chapter because it fits in well with the idea of photographing our pets and people friends when relaxing or sleeping. We're often conditioned to get "set up" and "made up" when we know people are going to take our pictures. In fact, many people don't even think of taking pictures unless they go on vacation or have a party or family gathering. Instead, consider taking photos of your loved ones on a Sunday morning in their pajamas just after they've brushed their teeth and grabbed (or fetched) the weekend paper, or late at night while watching a movie, or in the yard covered with dirt. Most pets seem to always be ready for their close-up, but they rely on us to grab the camera! If the moments are special to you, then those are the times you should be taking pictures.

Where'd My Sock Go?—Tips for Setting Up and Capturing Fun Photos

I always enjoy looking at collections of photos based on themes. A theme could be a series of images related to a topic like *cats who scuba dive*, or a picture collection of *firehouse dogs from around the world* (I'm trying to stay on topic here). In this chapter, I present a series of tips that read like themes or photo assignments. And unlike many of the assignments that we've all had in school, I promise that these will be fun … should you accept the challenges!

Please note: When you see notations like [w6.1], it means that a related Web link (and usually additional information) can be found by visiting the book's companion Web site at *www.PhotoPetTips.com.*

Tip #47
Photograph Your Cool Cat (or Dog) in Some Shades

88

Sunglasses or goggles can turn any feline or pooch into an instant star (at least in your photos), and the look can be absolutely hilarious. There are thousands of styles and options on the market, and here are a few quick tips for working with sunglasses:

- Use children's sunglasses or special sunglasses made for pets. The advantage to pet sunglasses is that they usually are safety tested and they often have adjustable straps with a Velcro (or similar) hook and loop fastener.
- Use a glasses neck strap to hold the sunglasses because they usually have soft caps to hide the sharp edges of the frames.
- Tie a rubber band or mini elastic hair band to the back of the neck strap after taking up the slack to hold it more securely to your pet's head. Just be sure not to make it too tight. In all cases, check the glasses to ensure that they don't have sharp edges or contain any glass—both can be potentially dangerous.

For this photo of Elwood sporting some very cool shades, we were outside on a beautiful day in May just after 4 P.M. I had him stand on a small table so that I could get a straight-on shot without having to lie on the ground. I shot it handheld (without a tripod), and was able to get a variety of different looks, including a number of profile views. The sunglasses were made especially for pets [w6.1] and Elwood didn't seem to mind wearing them. I cropped the photo here to a square, but it was originally shot as a horizontal image.

Camera: Canon EOS-5D;
Lens/Focal Length: Canon 50mm macro;
ISO: 400; *Aperture:* f/6.3;
Shutter Speed: $\frac{1}{800}$ sec;
Lighting Notes: The sun is slightly overhead and camera right, which created the lighting you see. No reflectors were used, but the Fill Light slider was moved to the right about one-third of the way in Adobe Lightroom when processing the file to help open the shadows on Elwood's face [w6.2].
photo © Andrew Darlow

> **"Be super cool by being super kind to animals!"**

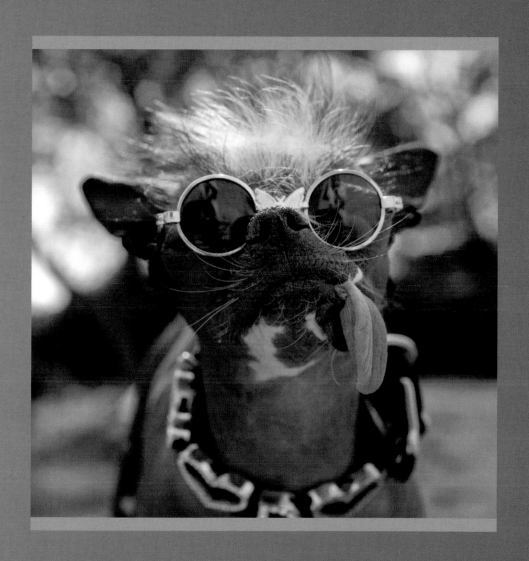

Tip #48

Capture Interesting Juxtapositions Between Pets and Artwork

As demonstrated earlier in the book (Tips 20 and 31), artwork and other furnishings can be used in your pictures to complement the actions and expressions of your pets. Some examples of art include quilts, distinctive pillows, statues, framed photographic prints and paintings. In this photo, taken at about 5 P.M. on a sunny day in May, the cat was just hanging out on top of the couch, appearing to be very wary of what the wolves' next move might be. I only had time to take a few shots before she decided to retreat. The vertical orientation helped make the photo more interesting because of the way the cat is tightly framed with the picture. The original image was not exactly square because it all happened so fast, so I straightened the photo when I cropped it, which leads to another tip: Don't throw out or overlook potentially strong photos just because the horizon is not perfectly straight.

Camera: Canon EOS-5D;
Lens/Focal Length: Canon 50mm macro;
ISO: 640; *Aperture:* f/2.5;
Shutter Speed: $\frac{1}{100}$ sec;
Lighting Notes: Lighting came primarily from a few windows located camera left. Some household lightbulbs provided additional fill light. Keep in mind that if you take a photo like this and use an on-camera flash, the flash will probably reflect back in the glass (like when shooting a flash into a mirror).
photo © Andrew Darlow

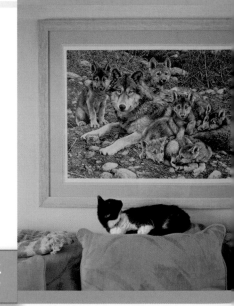

"Ummm ... need a mascot for your team, perhaps?"

Tip #49

Offer Some Treats and Photograph the Ensuing Action

It goes without saying that dogs and cats, like their people friends, love food, and some dogs will do almost anything for a treat. Dog trainers know this, and often use food as a reward for good behavior. Here are just a few ideas for using treats:

91

- Have someone stand just behind you with a treat to capture the dog's anticipation as you photograph the moment.
- Throw the treat toward the person who has the camera so that they can capture some action moving toward them.
- Throw the treat up so that your pet jumps to get it, and capture the moment when he or she is in the air.
- Make a line of treats over a specific area and photograph your pet as he or she travels from location to location to retrieve them.
- Hide a treat in an appropriate toy and capture the fun that ensues.

For the photo on the following page, shot on a cloudy day in mid-December at about 4 P.M., I watched as the dogs were given some treats, and then decided to capture the moment. I really like the angle of view in this photo, and how the dogs' emotions come out. The look was achieved with a wide-angle lens, and I got pretty close to the dogs (about 20 inches (50cm) away).

Every lens has a minimum focus distance, which is the distance from the film plane (or digital sensor) to the closest point at which you can achieve a sharp image. For the Canon 16–35mm f/2.8 lens I used, the minimum focus distance is about 11 inches (28cm).

"These are the low-carb, gluten-free treats, right?"

Camera: Canon EOS-D60;

Lens/Focal Length: Canon 16–35mm/16mm;

ISO: 400; *Aperture:* f/2.8;

Shutter Speed: ⅟₃₀ sec;

Lighting Notes: Lighting came almost entirely from the available lighting in the kitchen, which was an assortment of about six lights in different sizes. You can see a number of the circular catch lights in the dogs' eyes created from the kitchen's lights.

photo © Andrew Darlow

Tip #50

Photograph Some "Pet Parts"

On a number of occasions throughout the book I've suggested shooting at different zoom levels (focal lengths) to expand your creative options when photographing your pets and other family members. This tip builds on that idea and covers the wonderful world of photographing pet parts. That means you should look for interesting parts of your subjects to frame, such as close-ups of the nose, eyes, mouth, paws, teeth, or a curly tail.

93

Another related idea would be to just photograph a part of someone, but at the same time, include all of a dog or cat in the shot. For example, someone could be holding a dog or cat in his arms, but you can frame the photo so that you only see the person from his neck to his waist. A good example of that can be seen in Chapter 7, Tip 63.

For the photo of Elwood on the following page, shot on a beautiful day at about 4 P.M in May, I placed a silky black piece of cloth on the ground, and I quickly noticed his distinctive curled tail. This shot was my favorite from the group. Having a few background materials ready for times like these is another tip to consider [w6.3]. I also cropped the photo slightly to keep the focus on Elwood.

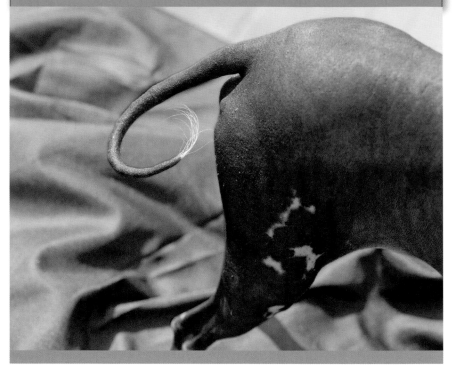

"From head to tail, I'm sharing the love!"

Camera: Canon EOS-5D;
Lens/Focal Length: Canon 50mm macro;
ISO: 400; *Aperture:* f/7.1;
Shutter Speed: ⅟₅₀₀ sec;
Lighting Notes: The sun is slightly overhead and camera right, which created the highlight and shadows you see. No reflectors were used.

photo © Andrew Darlow

Tip #51

Get Your Feet in the Game

This idea is related to the previous tip, and it involves a little foot-work. The range of shoes, sneakers, sandals, and, of course, unique in this world makes the inclusion of one's feet in the frame with a dog or cat both fun and interesting. It's easiest to do this when sitting, but it's also possible to include your feet in the shot when standing. In that case, a wide-angle lens generally works best. A related option would be to shoot someone else's feet with a dog or cat looking up at them.

95

For this photo of a yellow Labrador Retriever photographed in mid-December at about 4 P.M., I pointed my lens in the dog's direction and was rewarded with a smile. My lens was set to nearly its widest focal length (17mm), which is equivalent to about a 25mm lens (in 35mm terms) with the camera I used. The f/2.8 aperture contributed to the relatively shallow depth of field.

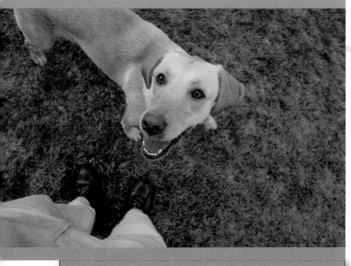

"Need a shine?"

Camera: Canon EOS-D60;
Lens/Focal Length: Canon 16–35mm/17mm;
ISO: 400; *Aperture:* f/2.8;
Shutter Speed: $\frac{1}{90}$ sec;
Lighting Notes:
Lighting came entirely from outdoor natural light filtered through the clouds.
photo © Andrew Darlow

Tip #52

Stack 'em Up! Photograph a Pet Sitting or Standing on Another Pet

96

If you have multiple dogs or cats you may occasionally find them sitting or standing on one another. As long as it is safe for everyone involved, the situation can make for very entertaining and heartwarming pictures. Little cats standing, sitting, or sleeping peacefully on the backs of big dogs are especially amusing to me. For this photo, photographed on a sunny day at about 4 P.M. in May, the Pit Bull was just trying to get some sun next to the sliding glass door when her Chinese Crested/Chihuahua–mix "sister" dropped in for a little surfing practice on her back. Everyone (well, at least the surfer) appeared to enjoy the experience.

I hung a curtain just behind them that I purchased from Ikea [w6.4]. It had some wrinkles in a few spots, so I did a little retouching on it using the clone tool in Adobe Photoshop. I also selected the fabric and applied a slight Gaussian blur in Adobe Photoshop, which is a tip covered in Chapter 9, Tip 93 that can be used to draw focus more toward the subjects and away from the areas you blur. Many software programs have the ability to make selections and blur selected areas. In addition, I lightened the top dog's face by selecting it in Adobe Photoshop because it was considerably darker than her body. I then lightened the Pit Bull's head a bit because it looked a bit too dark, and I added a catch light in his left eye. Last, I darkened the upper- and lower-left two corners of the frame very slightly to help bring the viewer's eye more toward the center of the frame [w6.5].

Camera: Canon EOS-5D;
Lens/Focal Length: Canon 50mm;
ISO: 320; *Aperture:* f/10;
Shutter Speed: $\frac{1}{125}$ sec;
Lighting Notes: Natural daylight (camera left) from the large glass door provided most of the lighting, and some overhead light from inside the room helped provide some fill light.
photo © Andrew Darlow

"Hang ten, dude ... then please get off me!"

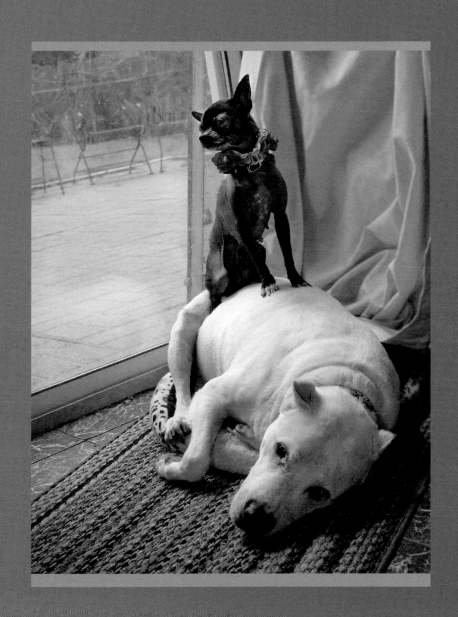

Tip #53

Look for Distinctive Tongues (and Cheeks)!

It is, of course, bad manners for people to stick their tongues out at one another. But when dogs and cats do it, it is quite natural, and can be very funny. I photographed this Rhodesian Ridgeback-mix with his large, distinctive tongue and his Terrier-mix friend at a client's home at about 3 P.M. in September. To me, it looks as though his tongue was handcrafted in a men's tie factory! And there is no shortage of tongue flapping in this book with Elwood and some of his friends gracing many of the pages!

Camera: Canon EOS-D60;
Lens/Focal Length: Canon 16–35mm/35mm;
ISO: 200; *Aperture:* f/5.6;
Shutter Speed: $\frac{1}{125}$ sec;
Lighting Notes: Natural daylight provided all of the lighting, and the trees helped provide the dappled lighting effect.

photo © Andrew Darlow

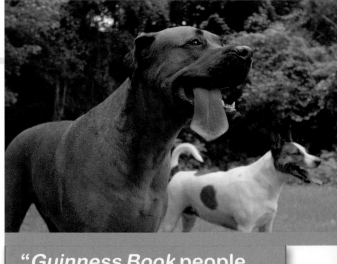

"*Guinness Book* people, I'm waiting for your call!"

Tip #54

Coordinate Your Dog or Cat to the Background

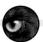

A background can make all the difference in a photo, so I recommend taking a quick walk around your home (including the bathrooms and outside) and see what areas might work well for this approach. For example, bright orange 1960's décor can really make a statement when your pet complements the look! Bed sheets and bedspreads can also make for great backgrounds. For this photo of a client's Dalmatian, the carpet and the dog had similar patterns, but were very different in color, which made for an interesting overall look. The overhead view and shallow depth of field also added to the effect.

99

Camera: Nikon N90;
Film: Fuji Sensia 200 Color Slide;
Lens/Focal Length: Sigma 28–105mm/ approximately 28mm;
Aperture, Shutter Speed, and ISO: unrecorded.
Lighting Notes: Light was streaming in from a large window (camera right), which created the strong highlights and slightly cool tones. A few lightbulbs were on in the home, and they added to the warmth of the picture, especially on the dog's head. No retouching was done apart from some minor dusting. The darkened corner effect was created by the shadows made by furniture in the room. If only a few corners were dark, I probably would have darkened the other corners in Adobe Photoshop to create the balanced look you see in this photo. Vignettes are covered in Chapter 9.

photo © Andrew Darlow

"Spots are the new stripes."

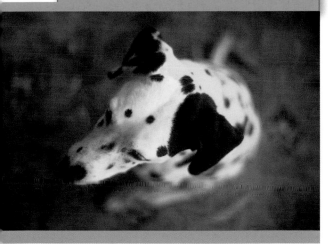

Tip #55
Photograph Your Dog Chewing on Something

This tip, and the title of this chapter, arose because a client's dog (which you see here) decided that a nearby sock would make for a great chew toy. I think that the expression is priceless, and it was no easy feat for the dog's owner to get the sock back! Other items that fall into this category include t-shirts, scarves, men's or women's underwear (including bras), and perennial favorites—designer shoes and expensive sneakers. There are always safety considerations with pets chewing on items that are not considered safe toys, so this tip is more a recommendation to capture the moment quickly if it happens, instead of setting it up on purpose. Safer options that you can explore include stuffed animals made for dogs and colorful chew toys [w6.6].

I only had a chance to get one exposure before the moment was gone, and because the lighting was low, the photo was not very sharp. I did some sharpening in Adobe Photoshop, which resulted in a bit of extra grain in the photo. Sometimes that's just fine—grain is not bad as long as you like the final look. Other retouching done to this photo included cloning out a piece of a chair's leg on the bottom left, and reducing saturation in the blue carpet and wood table in the back left of the frame. To finish things off, the edges were darkened slightly to draw attention toward the center of the frame.

Camera: Canon EOS-D60;
Lens/Focal Length: Canon 16–35mm/16mm;
ISO: 800; *Aperture:* f/2.8;
Shutter Speed: $\frac{1}{15}$ sec;
Lighting Notes: Indoor lighting from household lightbulbs provided all the light because everything happened so fast and there was no time to set up any special lighting!

photo © Andrew Darlow

"They come in pairs, so can't we share?"

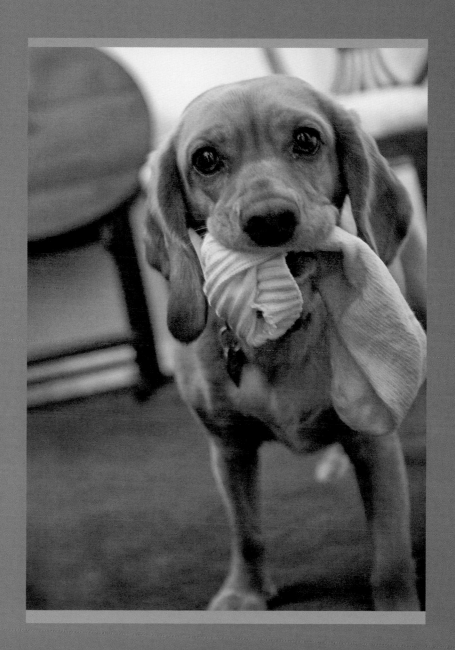

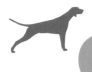

Tip #56
Photograph Someone Happily Holding Multiple Pets

Multiple pets, whether of the same breed or various mixes, can be cute when held one at a time, but even cuter when multiple pets are held up for the world to see. Of course, use care when holding multiple pets—it's not a contest. You can also have a few people stand or sit next to each other, each holding a few puppies or kittens for a more continuous look and feel.

For this photo of a client and her three adorable Maltese, she wore a beautiful dress, and while sitting in her home in front of a fireplace, she held her dogs all together (and very carefully). I took about 25 exposures of the group, and even then, I had to borrow from a few different images to get good expressions for all the dogs because they were constantly moving. Other retouching included some color correction to make the dogs more neutral in color. Also, selective sharpening was done in Adobe Photoshop to make the dogs stand out from the background, and to avoid sharpening the woman's skin, which is another tip to consider.

Camera: Nikon D1X;
Lens/Focal Length: Nikkor 50mm;
ISO: 200; *Aperture:* unrecorded;
Shutter Speed: $\frac{1}{10}$ sec;
Lighting Notes: The lighting that created the subtle edge light on the left of the frame came from a large picture window camera left. A bare-bulb lightbulb placed in a lamp (camera right) and two flashlights added interesting catch lights and dappled lighting effects to my client's face as well as her dogs. The mixed lighting (different color temperatures) created a warmish glow on her face and on the dogs when setting the camera to daylight color balance. The daylight was about 5000°K and the lightbulb and flashlights were about 3500°K. (See Chapter 1, Tip 4, for more about color temperature.)

photo © Andrew Darlow

> "I'm the cutest! … No, I am! … No, I am!"

Tip #57
Capture Dramatic Side-by-Side Size Contrasts

When I think of size contrasts and pets in photos, Elliott Erwitt's well-known black-and-white 1974 photo entitled "Dog Legs" comes immediately to mind. In the photo, shot from a very low perspective, a Chihuahua stands next to a woman with black boots, and she is standing next to a very large dog. If you have a few pets of varying sizes, get them together and shoot from various angles to emphasize their size differences.

For this photo of Elwood and his "brother," a large German Shephard, we encouraged Elwood to take a seat next to him. I experimented with a few angles, and both of them handled the assignment well.

Camera: Canon EOS-5D;
Lens/Focal Length: Canon 50mm macro;
ISO: 640; *Aperture:* f/8;
Shutter Speed: $\frac{1}{100}$ sec;
Lighting Notes: Lighting came primarily from a single off-camera diffused flash (Vivitar 285HV), placed slightly camera right. Natural daylight from a few windows located behind the camera provided some additional light.

photo © Andrew Darlow

"Hey Elwood ... say cheeeeese!"

Tip #58

Capture Pets In and Around Water

There are countless opportunities for photographing dogs near the water, including lakes, rivers, pools, the beach, outside in the sprinklers on a summer day, or even in the bathtub. Watch your gear during the inevitable "power shake" that so many dogs like to perform after they get wet. A clear screw-on skylight filter can be invaluable in those situations to help protect your lenses [w6.7], and some companies make special bags and housings for cameras [w6.8].

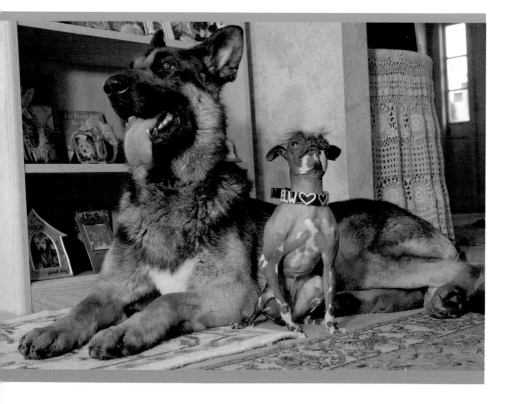

Tip #59

Use Simple Props to Make a Picture Much More Interesting

Simple props—scarves, bandanas, hats, angel/butterfly wings, pool/bath toys, and just about anything else that complements your pets and their people friends—can transform an otherwise average photo into something far more interesting. Furniture can also be a prop, and it works especially well if you keep the background simple and use a distinctive chair or bench. Many companies make chairs and benches especially for kids and pets, and some companies produce very elegant furniture designed for pets [w6.9].

I photographed this Pug puppy outside under a tree at about 1 P.M. in late August. I asked the dog's owner if she would place the baby pacifier in the dog's mouth. That's not something I would recommend anyone do unless they have a very close relationship with the dog or cat! The pacifier was new and clean, and I brought it with me in a plastic bag. It's always best to clean any toys in advance that you plan to offer to a dog or cat.

"Where did I sign up for this?"

Camera: Canon EOS-D60;
Lens/Focal Length: Canon 50mm macro;
ISO: 400; *Aperture:* f/8;
Shutter Speed: $\frac{1}{80}$ sec;
Lighting Notes: Shaded natural daylight provided all the lighting, and the tree provided the nice dappled light effects.

photo © Andrew Darlow

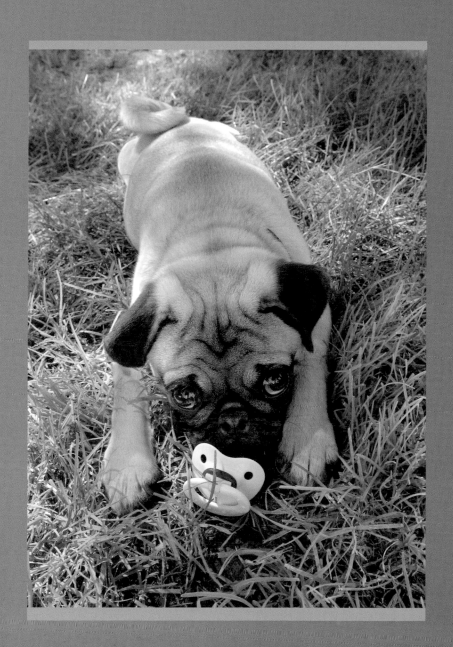

Tip #60

Capture Some Interesting Profile or Partial-Profile Views

This tip is one that is very easy to do, but it is often overlooked. Look for opportunities to photograph the profiles of your pets as they turn to look in different directions. There are full profile views, partial profiles, and everything in between. It's especially interesting if the dog or cat is looking at something or someone that you also include in the photo, such as a cat looking at a dog.

For this photo of Eric Udler, founder and President of the Super Pet Expo, and his Weimaraner named Chandler, the dog looked away for a moment and I was able to get this shot with Eric slightly out of focus in the background [w6.10]. It was photographed in a park on a partly cloudy day at about 1 P.M. in late December. Here's another tip: Have your people subjects sit or stand just behind a dog or cat to allow the pet to be the focal point of the image. If the pet looks away and the person looks at the camera, it can produce a great effect. In Chapter 2, Tip 14, I also included a photo of Chandler when describing a "hero shot." In that case, a profile view was combined with a low viewpoint for a very different look and feel.

Camera: **Canon EOS-D60;**
Lens/Focal Length: **Canon 50mm Macro;**
ISO: **400;** *Aperture:* **f/8;**
Shutter Speed: **$\frac{1}{180}$ sec;**
Lighting Notes: **Daylight diffused through the clouds in the sky provided all the lighting.**
photo © Andrew Darlow

> "My sidekick is a nice guy, but I call the shots around here."

108

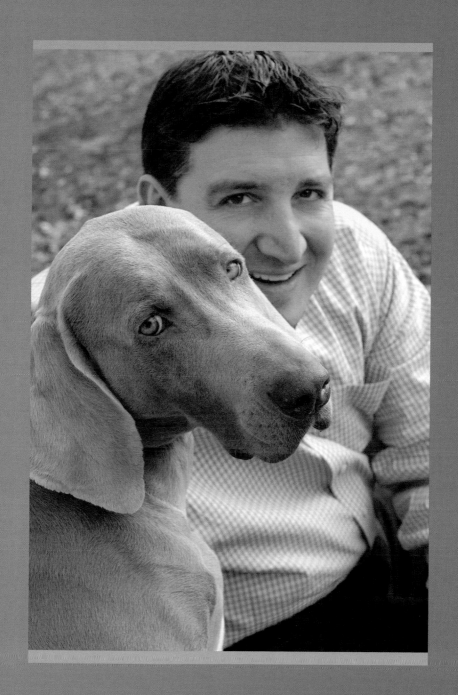

Tip #61

Photograph Dogs and Cats When You Travel, Live, or Work in Other Countries.

110

I've been fortunate to have lived, studied, worked, and traveled in Europe, Asia, and North America. Just about everywhere I've been, I've seen dogs and cats in homes, walking with their owners on the street, and in some cases, I've seen them just roaming around on their own. There are rules of etiquette (and possibly laws) governing photography in different countries, so I recommend doing some research about the places you are visiting, and if the pet's owner is there, always ask permission. It's a good idea to write down the translation for a statement like: "Excuse me, may I photograph you and your dog (or cat)?" There are many questions that come up regarding model releases and what type of publication use is permitted for such photos, so I recommend reading some of the resources on the book's companion Web site [w6.11].

I took this photo of a neighbor's cat who often came to visit my apartment near Osaka, Japan, when I was an exchange student during college. I love these types of photos because they include details that are very different from my home country, such as the Japanese-style sliding windows and the hot water heater over the sink. I also really like photos that are not posed, and that just capture moments in time. Of course, you can use these tips wherever you find yourself. Just look for scenes like this as you go about your day—while cooking, cleaning, relaxing, traveling to work, and while you're just living life.

Camera: **Minolta Freedom Zoom 90 (35mm);**
Film: **Fuji Color Negative;**
Lens/Focal Length: **Fixed-zoom 38–90mm;**
Aperture, Shutter Speed, and ISO:
unrecorded.
Lighting Notes: **The natural daylight that came through the sliding window provided much of the light, and an overhead light in the kitchen provided the rest.**

photo © Andrew Darlow

"Hmmm, how do I say 'miruku onegai shimasu' in English?" [Translation at w6.12]

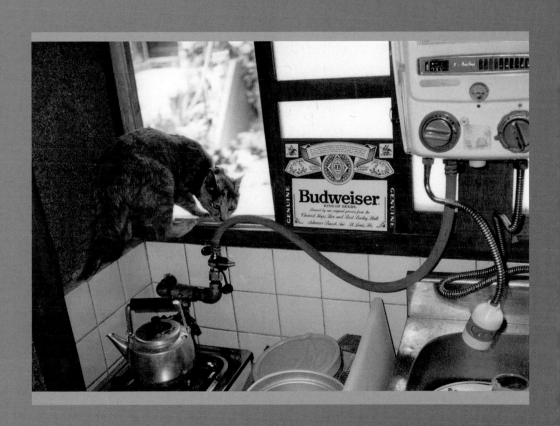

Holidazed and Confused: Photo Tips for Holidays and Events

Holidays and events are an important part of so many of our memories. Weddings, holidays, birthday parties, school trips, and other events and celebrations all make for great photo opportunities. In this chapter, I make specific suggestions for capturing memories of holidays and events. And even if you don't celebrate some of the holidays mentioned, there will be generic tips throughout the chapter that will hopefully help make your photos even more memorable.

Please note: When you see notations like [w7.1], it means that a related Web link (and usually additional information) can be found by visiting the book's companion Web site at *www.PhotoPetTips.com*.

Tip #62

Capture Memories of Christmas, Chanukah, and the New Year

114

The winter holidays of Christmas, Chanukah, and the New Year (summer holidays in the southern hemisphere) are filled with opportunities to take pictures of our pets and other family members. Photo ideas include:

- Pictures of just the pets (or with other family members), near the fireplace or in front of a Christmas tree or Chanukah candles/lights.
- A photo of the whole family in the front of a home decorated for the holidays (day or night).
- Photos taken around your local town or even in front of shopping store displays during the holidays (such as the famous displays at Macy's in New York City), can capture the spirit of the holidays in so many ways.

I photographed this Boston Terrier, Cupid, just before Christmas outside her family's home under some trees at about 1 P.M. See Chapter 2, Tip 16, and Tip 70 later in this chapter for two indoor photos of Cupid. The sleigh was the perfect size for Cupid, and it looked as though she and her assistant were ready to give Santa a helping paw or two (or four)! I also selectively sharpened Cupid's face to help her stand out a bit more.

Camera: Canon EOS-D60;
Lens/Focal Length: Canon 28–135mm IS/28mm;
ISO: 200; *Aperture:* f/11;
Shutter Speed: ⅟₁₂₅ sec;
Lighting Notes: Natural daylight shaded by trees provided much of the lighting, and a single diffused off-camera flash provided some fill light. The off-camera flash also provided the catch lights in everyone's eyes.

photo © Andrew Darlow

> "Mr. Snuggles, fire up this bad boy!"

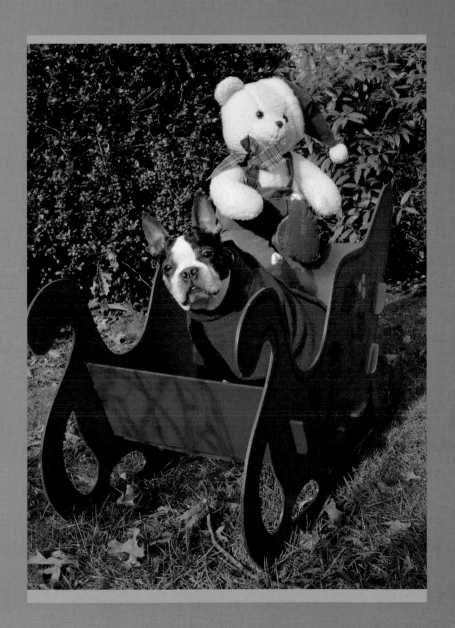

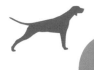

Tip #63

Photograph Your Family When Watching or Participating in Sporting Events

Pets and team merchandise can be a very funny (and expensive!) combination. You can express your love for your favorite teams by outfitting your dog or cat with shirts, jackets, or other gear specifically made for them (or you may be able to use or alter human clothing slightly to make it fit). Even more photographically interesting is to have pets match the rest of the family on game day. However, don't just limit the fun to professional team wear. Consider making outfits with the same colors as the Little League baseball or football teams in which your family participates, or buy shirts or sweaters with matching colors. Then hit the field (or backyard) and capture the color-coordinated fun! Consider the low-light and action tips in Chapter 1, Tip 11, as well as in Chapter 8 for when you are photographing moving people and pets.

I photographed this man and his Chinese Crested at about 2 P.M. in April at an outdoor dog agility event in which the dog was participating. I asked for his permission and then photographed both of them from a number of different angles, and in both horizontal and vertical orientation. I chose this image because I think it captures the special bond between a man and his sports-loving pooch. I added the catch lights you see in the dog's eyes to help give more sparkle and life to the photo. I also selectively sharpened the dog's face to draw more attention to her eyes, and I made her face a bit lighter and more contrasty so that she would stand out more from the background.

Camera: Canon EOS-D60;
Lens/Focal Length: Canon 28–135mm IS/28mm;
ISO: 200; *Aperture:* f/5.6;
Shutter Speed: $\frac{1}{2000}$ sec;
Lighting Notes: Natural daylight on a clear day provided all of the lighting.
photo © Andrew Darlow

"J-E-T-S, Go JETS!"

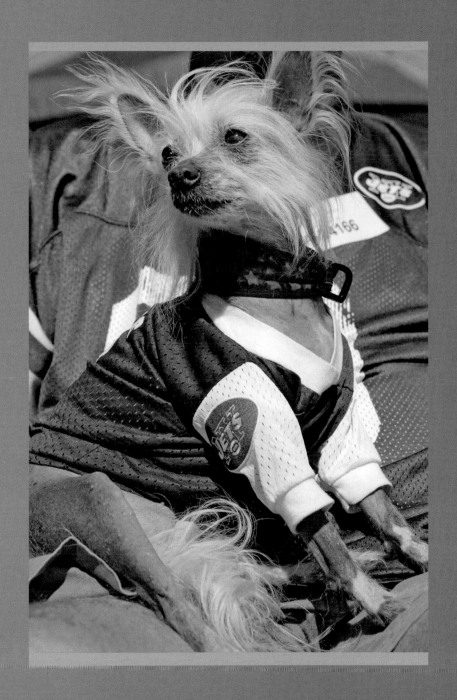

Tip #64

Photograph Your Pet with Bunny Ears for Easter or Halloween

Easter is observed by more than a billion people worldwide, and like Christmas, it is a religious holiday that in some countries has a component to it that is celebrated even by those who are not of the Christian faith. Easter egg hunts, coloring Easter eggs, and exchanging candy are some examples of how Easter is celebrated. The Easter Bunny is a part of that tradition, and because of that, adjustable bunny ears are sometimes worn by people and pets around Easter [w7.1]. Halloween is another time that bunny ears are commonly worn, though you should not expect them to stay on very long—I haven't met a dog or cat who enjoys wearing them. That being said, the photos you can get of dogs or cats wearing bunny ears is nothing short of hilarious!

For this photo of a Doberman Pincher photographed indoors during a Kennel Club dog show, I asked the dog's owner to put the bunny ears on him (always the best option if you don't know the dog or pet very well). I really like the expression on his face and how the ears sit on his head. I selectively sharpened his eyes a bit to draw a bit more focus there, however, the focal point is clearly on his nose, which I think is interesting.

This takes patience of course, so be persistent if you want to get usable images. And if the dog or cat is very uncomfortable with the whole process, I recommend trying something that doesn't require placing anything on the pet's head.

Camera: Canon EOS-D60;
Lens/Focal Length: Canon 16–35mm/35mm;
ISO: 200; *Aperture:* f/8;
Shutter Speed: 1/60 sec;
Lighting Notes: Lighting came from a studio strobe light (flash unit) placed behind a large translucent disk reflector. That produces both a soft light, and nice catch lights in the eyes. A second strobe light was used for the background. See Chapter 8 for more on tips for lighting with studio strobes.

photo © Andrew Darlow

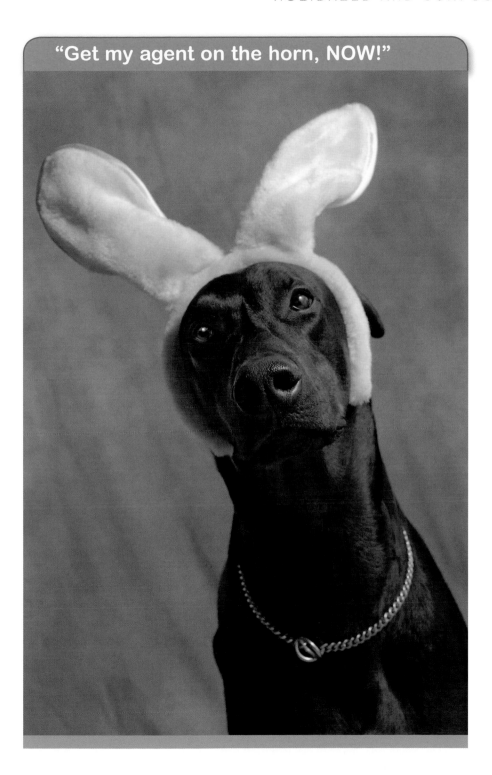

"Get my agent on the horn, NOW!"

Tip #65

Photograph Your Pet in Halloween Garb

Halloween is also a holiday celebrated by millions of people world-wide. Many celebrate Halloween by dressing up in costumes, so consider making or purchasing a costume for your pets. Some quick costume ideas include:

- A ghost—a white costume can be made from a sheet, fabric, or t-shirt.
- A witch—a small hat can be purchased, and optionally, a black costume can be made from a sheet, other fabric, or t-shirt.
- Jack-o'-lantern—an orange costume can be made from an orange sheet or other fabric, with cut-out black shapes glued or sewed onto the fabric.

There are a multitude of pet Halloween costumes available in stores and online [w7.2].

For this photo of a friend's black-and-white cat photographed in May at about 4 P.M., I asked his owner to place a soft black top hat on his head, which I adjusted slightly to make it look more like a witch's hat. The top hat was part of a "cap and tails" outfit for dogs. I cropped the photo fairly tight to focus on his expression and the hat. You don't always have to include every square inch of a costume or a pet. It's the overall look and impact that a photo makes that is most important.

> "You've got 12 seconds before my next scheduled nap."

Camera: Canon EOS-5D Mark II;
Lens/Focal Length: Canon 16–35mm/35mm;
ISO: 2000; *Aperture:* f/3.5;
Shutter Speed: $\frac{1}{60}$ sec;
Lighting Notes: All lighting came from daylight streaming through a large window with vertical blinds that were opened slightly. The window was about 8 feet (2.4 meters) from the cat, and it produced one catch light seen in the cat's right eye (the catch light in the cat's left eye was added in Adobe Photoshop by cloning the catch light from his right eye to his left eye). Some additional fill light came from the white carpet, which acted like a reflector.

photo © Andrew Darlow

Tip #66

Take Photos At a Dog or Cat Show (or Related Event)

There are many, many dog and cat competitions held around the world. Some are very organized, like the events sanctioned by the AKC (American Kennel Club). Others, like The Great American Mutt Show, are much more casual [w7.3]. I've photographed many dog shows over the years, and for those who have pets competing, they can be a great place to meet other dog owners and to photograph your pets. Even if your dog or cat does not win a ribbon or trophy, there are always a few good spots around the facility where you can take pictures. The benching area (where pets and their handlers get ready) is a great place because you can take photos as the pet is getting prepped. The transformation that some dogs and cats undergo is nothing short of amazing!

Photographing agility events properly takes some planning and expertise. These events include lure coursing and agility (weaving in and out of poles, and jumping through rings). The best general advice I can give for photographing agility events is to follow the action and sports photography tips in Chapter 1, Tip 11.

I photographed this woman and her adorable Chihuahua-mix at an event called The Great American Mutt Show [w7.4]. Despite the show's name, purebred dogs are also welcome to participate. A portion of the proceeds from their shows always goes toward supporting animal rescue and awareness, and this particular show was held during one of the Super Pet Expos.

Camera: Canon EOS-D60;
Lens/Focal Length: Canon 16–35mm/35mm;
ISO: 400; *Aperture:* f/6.7;
Shutter Speed: $\frac{1}{20}$ sec;
Lighting Notes: A single diffused on-camera flash provided much of the lighting, but additional lighting came from the natural daylight coming from the windows, as well as some fixtures above. The shutter speed allowed for a nice balance between flash and ambient light.

photo © Andrew Darlow

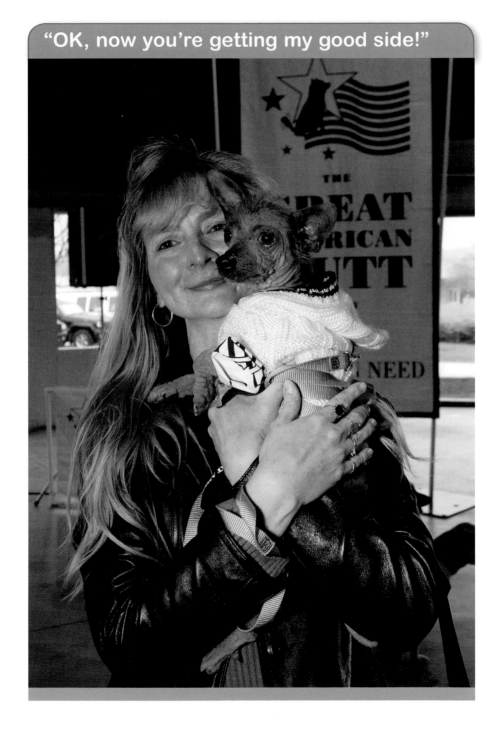

"OK, now you're getting my good side!"

Tip #67

Take Pictures at a Pet Expo/ Trade Show

Pet expos that allow leashed dogs and cats are a great place to get some unique images. One such event that I've been attending and photographing at for years is the Super Pet Expo, held in various locations throughout the year in the eastern part of the United States [w7.5]. At many of their shows, pets on leashes are welcome to bring along their owners (if pets could drive, I'm sure they'd do just that!). Here are a few suggestions for taking pictures at a pet-related expo:

- Look at your pet to see what he or she may be interested in doing. If he or she seems to want to play in a specific area, such as an enclosed dog run, take some photos of your pet there.

- If your pet finds a furry friend or two (very common at these shows), take a few photos of them together (with the permission of their owners of course).

- The lighting at expos is generally not very bright so the low-light tips in Chapter 8 should come in handy when dealing with this issue.

- Capture photos of booths that represent causes that you support and about which you want to spread the word. Many pet expos (including the Super Pet Expo) have booths with specific breed rescue organizations, such as Greyhound Rescue groups [w7.6], general rescue groups like Rogers' Rescue [w7.7], or animal protection organizations like the Humane Society [w.7.8].

I took this photo of the Pets with Disabilities booth [w7.9] and one of its mascots named Duke at the Super Pet Expo in New Jersey. The organization does outstanding work, and like so many other nonprofit rescue and rehabilitation groups, they need a lot of support to operate. By taking photos like these and sending them to friends and family, more people can learn about organizations that are working hard to help others.

I chose a low viewpoint for this photo, and I would not be concerned if a dog or cat has something or someone in front of them—it can make for a very interesting image. This type of photo is similar to what you might find in a newspaper. It isn't posed, and the subjects look like they are hard at work, spreading the word about their organization—and I'm pretty sure that they were! I chose the cropping you see because of the way it helps focus the eye on the main subjects.

125

"Yes, I'm that hunky dog on the cover of our calendar."

 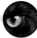

Camera: Canon EOS-D60;
Lens/Focal Length: Canon 16–35mm/35mm;
ISO: 400; *Aperture:* f/4;
Shutter Speed: ⅟₃₀ sec;
Lighting Notes: Lighting from overhead fixtures inside the exhibition hall provided most of the lighting, and some daylight from windows surrounding the exhibition hall added to the overall lighting.
photo © Andrew Darlow

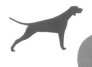

Tip #68

Photograph the Action at a Parade, Fair or other Event

Parades, fairs and other events are great places to bring pets as long as they are permitted, and as long as they can handle crowded situations. One big concern at street fairs and parades is that pieces of food are often dropped on the ground as people walk and eat, and some dogs become walking vacuum cleaners in those situations. If one person is the dog walker and the photographer or another family member acts as the food cop, you will have a better chance of avoiding unpleasant "issues" later on.

Here are a few specific ideas for taking photos at these types of events:

- Dress up your pets to match the theme of the parade. For example, for a St. Patrick's Day parade, dress them in green, and for a Thanksgiving day parade, outfit them in pilgrim costumes. You will definitely get some attention from others!

- Hold up your dog or just photograph him or her on the ground in front of interesting color schemes such as a wall of t-shirts, or in front of various food stands such as a big sign that reads "HOT DOGS."

- Take pictures of your pets and other family members with the event's banners and/or signs showing. New York City's San Gennaro Feast, held each September in Little Italy, comes to mind immediately with regard to this suggestion [w7.10]. By having the signs in the photo, you will more easily be able to recall where and when the photos were taken.

Camera: Nikon N90;
Film: Kodak E100S (color slide);
Lens/Focal Length: Sigma 28–105mm/
approximately 50mm;
Aperture, Shutter Speed, and ISO: unrecorded.
Lighting notes: Lighting was entirely from direct natural sunlight almost directly overhead.

photo © Andrew Darlow

"Good thing I had my hair done yesterday."

Tip #69

Consider Including Your Pets in Your Wedding

Ever since Tiger from the Brady Bunch made a mess of Mike and Carol Brady's wedding, dogs have had a difficult time getting on guest lists. Places of worship may have specific pet policies, and the wedding reception is usually not the best place for a pet, but both are options to consider when planning a wedding. Another idea is to consider bringing the family dog or cat to the rehearsal dinner for a few quick group photos. Some quiet photos with a groom or bride alone with his or her dogs or cats can also be priceless—and perfect for the wedding album.

If you look for shooting opportunities before, after and during a wedding (or any other event, for that matter), you may be surprised how many satisfying images you will come home with. At about noon on a perfect October day while in San Diego for a friend's wedding, we came across the "Blessing of the Animals" ceremony outside a church. After asking permission, I took a few photos of this beautiful dog. I was shooting film and didn't note the aperture, but it was probably about f/4 due to the shallow depth of field.

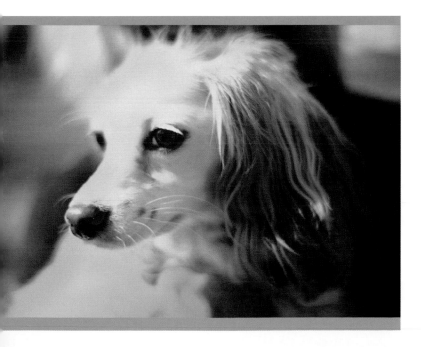

Tip #70

Take a Few Valentine's Day Photographs and Create Your Own Cards

Valentine's Day is celebrated by hundreds of millions of people worldwide, and the history of St. Valentine and Valentine's Day is very interesting [w7.11]. The color red is a symbol of love and the predominant color of Valentine's Day, so consider dressing up your dog or cat in something red (even a red scarf or boa will do).

Like the photo in Tip 16 in Chapter 2, I photographed this Boston Terrier named Cupid inside her home for a full-page feature in a magazine's February issue. I photographed her from a few distances with a fixed–focal length 50mm lens, and this was the one that was chosen. This photo was also used for a number of cards that I printed for the dog's "mom" using an inkjet printer and inkjet-compatible prescored papers. She then distributed the cards to friends and family around Valentine's Day and at other times. There are many fantastic inkjet- and laser-compatible prescored papers for making cards, or you can make your own by printing, cutting, scoring, and folding them [w7.12].

"Won't you be mine?"

Camera: Canon EOS-D60;
Lens/Focal Length: Canon 50mm;
ISO: 800; *Aperture:* f/3.5;
Shutter Speed: $\frac{1}{45}$ sec;
Lighting Notes: Most of the lighting came from two small off-camera flash units, which created the two catch lights seen in the dog's eyes. Some additional fill light came from a large picture window.

photo © Andrew Darlow

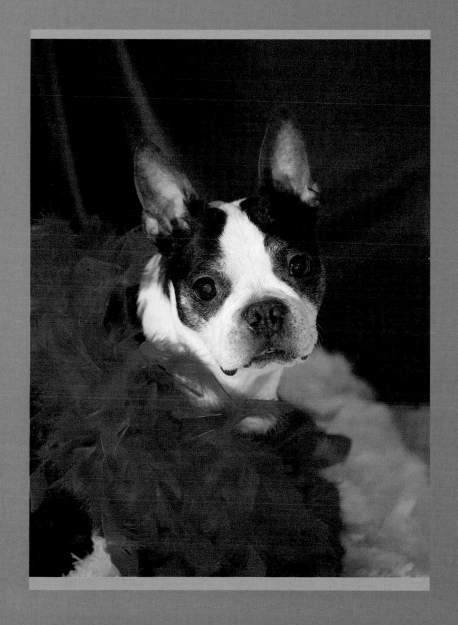

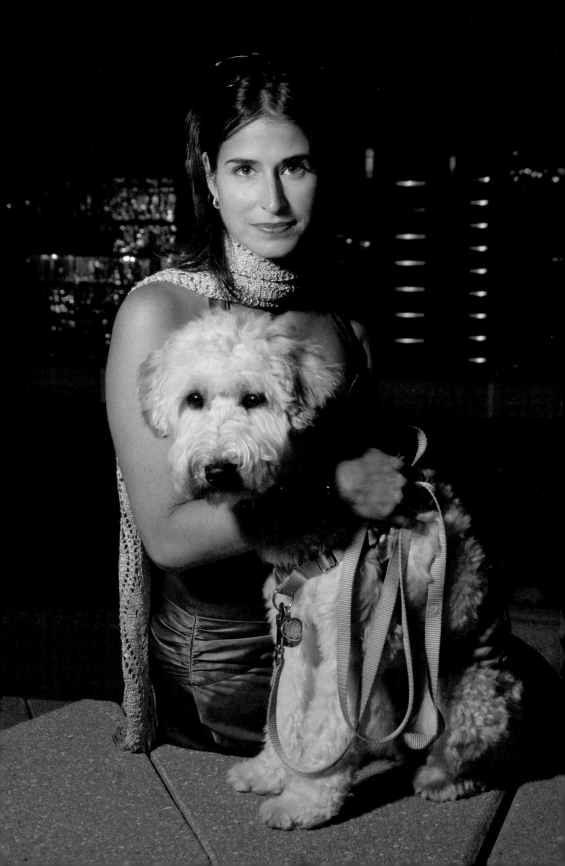

Barkness on the Edge of Town: Low-Light and Creative Lighting Tips

Photography is all about capturing light, and throughout the book I've covered various lighting tips for photographing pets by describing the lighting used. In this chapter, I present tips for getting better photos in dark and low-light situations with different types of cameras, and for lighting with flash units, whether the flash is built into the camera or separate. To delve deeper, there are many books and Web sites that cover creative lighting, including camera-specific books that go over the nitty-gritty of exactly which buttons to press on your specific camera and/or flash unit, and where they are located [w1.26]. And of course, there's the user's manual, which always makes for exciting reading!

Please note: When you see notations like [w8.1], it means that a related Web link (and usually additional information) can be found by visiting the book's companion Web site at *www.PhotoPetTips.com*.

Photo on facing page © Andrew Darlow [see Tip 80 for image information]

Tip #71

Shoot in RAW Mode for Best Results

This tip is also covered in Chapter 1, Tip 2, but it is so important that I added it as the first tip in this chapter. When you use your camera's RAW capture mode, you can edit your images much more effectively because the RAW files retain more information and generally exhibit less noise at the same ISOs compared with shooting in other modes, such as JPEG or TIFF. In fact, you may be surprised how a very dark or contrasty photo can be adjusted and look great because you shot it in RAW mode. That being said, some cameras do not have a RAW capture option, and many people understandably like the convenience of being able to just take pictures and upload them quickly to a blog or site like Facebook.com or Flickr.com. Others just want to bring their media cards to a lab or retail store to have prints made quickly, without having to process RAW files through a special application.

Whatever options you choose, it's really about selecting and using a system that allows you to make photos that you can share with friends, family, and future generations.

For this photo of a client's cat, photographed in front of a window, some of the highlight areas would probably have been blown out and unable to be retrieved had this been shot the same way in JPEG mode. By shooting in RAW, I was able to retain detail in both the highlights and shadows by making some adjustments in a RAW file-processing application (in this case, I used Adobe Photoshop Lightroom). For situations when there is a very wide contrast range, you can process the same RAW file twice (once for the highlights and once for the shadows), then combine the photos in Photoshop or another application, as described in Chapter 9, Tip 95.

"I hope you know we just went into overtime."

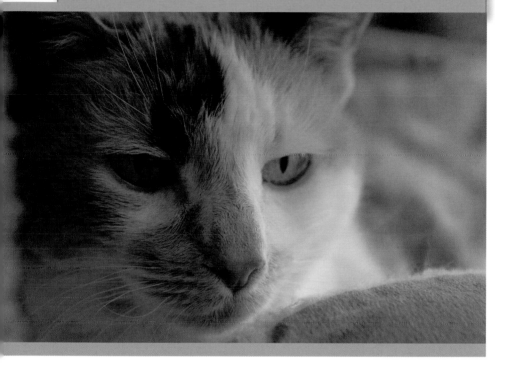

Camera: Nikon D300;

Lens/Focal Length: Nikkor 24–70mm/70mm;

ISO: 640; *Aperture:* f/5;

Shutter speed: $\frac{1}{125}$ sec;

Lighting Notes: Lighting came from a combination of daylight from a large window, as well as a small flash unit (Nikon SB-900) shot into a 40-inch-diameter (102-cm) Lastolite All In One Umbrella (camera right, and fitted with its white insert). That produced most of the light on the right, and some of the catch lights in the eyes.

photo © Andrew Darlow

Tip #72

Choose Higher ISOs with or without Flash, but Consider the Noise

134

When you shoot in relatively low-light situations and turn off your flash, many creative options are possible. However, unless you have a tripod and your subjects don't move, you need to find a way to make short exposures so that your pictures are sharp, especially when photographing active subjects like dogs and cats.

The key is not to adjust your ISO so high that your photos contain excessive noise. You can judge what is excessive noise by looking at your photos at a few different zoom levels, as well as in prints. There are also some software programs that can effectively help to reduce noise [w8.1]. The tips related to action and sports photography in Chapter 1, Tip 11, can also be applied to low-light photography. And though many adjustments can be made later to RAW files, such as color temperature settings, it is important to choose your ISO wisely in the camera before you shoot. Also, even when using a flash unit, it's a good idea to choose an ISO that is not too low so that your flash doesn't have to work as hard (this is especially important with battery-powered flash units). If you use less power, your flash should refresh faster. Waiting for a flash to refresh can be frustrating when you are getting great expressions from your subjects.

Displayed here are a few of the flash options for the Canon PowerShot SD790 digital camera. In this camera's Manual (M) or SCN (scene) modes you have the following three options (displayed from left to right): Auto flash (the camera engages the flash if it thinks it needs it); Flash on (very useful for fill flash as described in Tip 33); and Flash off (as described in Tip 73).

photo © Andrew Darlow

Tip #73

Turn the Flash Off in Certain Situations for More Natural-Looking Photos

Most people set their camera to automatic mode and trust it to expose scenes acceptably. But in many situations, it's far better to turn your flash off and use a few techniques for getting more natural-looking pictures of your pets and other family members. Most cameras (even fancy DSLRs) will take a reading, and if the lighting appears too dark to the camera's meter to produce a sharp photo, the camera will either cause the flash to fire, or it will engage the pop-up flash to let you know that it is about to fire when you press the shutter release. This is especially important with camera phones, as discussed in Chapter 1, Tip 1.

135

As I mentioned in Tip 72, the first place to start when you want to take pictures in a low-light situation without the flash is by setting your camera's ISO to the lowest value that allows you to get the types of pictures you want, with a level of noise that you find comfortable. That may be as low as ISO 100 if you have a tripod and are shooting static objects, or as high as ISO 3000 if you want to freeze action in certain low-light situations. Then turn off your flash (on most point-and-shoot cameras, look for a lightning bolt icon and press it until you see a line go through it). Some point-and-shoot cameras won't let you turn off the flash when the camera is in auto mode, so you may need to go into the menu to turn off auto mode, and then the flash. For DSLRs with a pop-up flash, check your camera's manual to see how to best disable it. Manual mode is also an option in these cases.

Below are suggestions for situations when you'll probably want to turn off your camera's flash:

- When you have a large window, mirror, or glass in front of your subjects, because the flash will create a starburst effect.
- When you want to capture the ambient light in the background (especially if the background is far away), like at a concert or from the stands at a dog or cat show.

- Any time you want to capture the look of the light you see in front of you. Examples of lights you can use include overhead lights, flashlights, or even car headlamps. Most modern digital cameras have a live-view LCD or live-view option, so seeing a good approximation of what you are going to get on a 2- or 3-inch screen is a big plus.

Another tip is to "paint with light" by shining light from a flashlight or other light on your subject and moving it as you expose the image. I used this technique in Chapter 6, Tip 56, to create a dappled light look, as well as Chapter 4, Tip 33. You will almost always want to place your camera on a tripod so that you can set the exposure from about $\frac{1}{60}$ sec to more than a minute. This will retain sharpness in the areas that do not move. Manual mode is usually the best option when using this technique. Just keep in mind that anyone who moves will be blurred if the shutter speed is not fast enough [w8.2].

I took this photograph of a client's Maltese resting in a very nicely decorated home in New York City at about 4 P.M. in May. The sunlight streaming in from the windows of the home was magnificent, and I really like how the light falls on the chair and furniture. The dog is relaxing in the shade under the table, and definitely looks like he's at home.

Tip #74

Choose Backgrounds and Place Them a Proper Distance from Your Subjects

Using backgrounds such as muslin, set paper (a.k.a. seamless), artificial silk, and canvas can help make your photos look as though they were photographed in a professional studio. There are hundreds of options for backgrounds, from inexpensive curtains from a store like Ikea (see Chapter 6, Tip 52, for an example) to hand-painted canvas with intricate designs [w8.3].

137

The distance you choose from your subjects to the background is important. Generally, more distance is better, which may require the use of a separate light or two just for the background. Advantages of more distance from subject to background are that you can light it independently from the subjects, and it can be made to go out of focus so that any defects or unwanted creases are minimized. Many materials can be "dewrinkled" by using a hand-held steamer [w8.4].

I photographed this lovely Papillion (p. 138) at about 4 P.M. on a clear day in March. The background was a light-brown, hand-painted muslin, and it was hanging about six feet behind the table. I really like the way it contrasts with the soft red fabric that's on the table. The dog's face and body were selectively sharpened and some cloning was done on the background in Adobe Photoshop to reduce some of the lines and wrinkles.

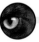

"I proclaim this my spot from now on!"

Camera: Nikon D1X;
Lens/Focal Length: Nikkor 50mm;
ISO: 200; *Aperture:* unrecorded;
Shutter Speed: $\frac{1}{15}$ sec;
Lighting Notes: The lighting for this image is coming almost entirely from the windows. A few lightbulbs inside the home add to the warm tone of the image.

photo © Andrew Darlow

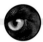

> "Too happy-go-lucky? I'll work on that."

138

Camera: Canon EOS-D60;

Lens/Focal Length: Canon 16–35mm/33mm;

ISO: 200; *Aperture:* f/6.7;

Shutter Speed: $\frac{1}{90}$ sec;

Lighting Notes: A single flash unit (studio monolight strobe) with a 40-inch translucent white circular reflector in front of it, placed about 4 feet from the subject, provided most of the lighting on the dog. A second studio monolight provided lighting for the background, which was about six feet behind the dog. Additional lighting came from natural daylight coming from windows to the right. A white reflector card was placed camera left, just out of the frame.

photo © Andrew Darlow

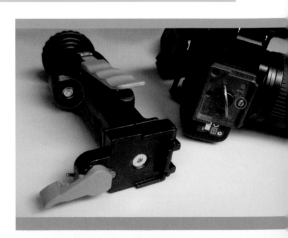

Tip #75
Use a Tripod or Monopod in Low-Light Situations

A tripod (and in some cases, a monopod) can be an invaluable tool for any photographer. I covered tripod-related tips in Chapter 2, Tip 21. In addition to stabilizing cameras, tripods can also serve as light stands, reflector holders, or background stands, and many tripods have quick-release plates that you can attach to your camera. When you are ready to use the tripod, the plate quickly attaches to the tripod and you're good to go.

A related tip is to bring a bubble level with you when you use a tripod to make sure that the horizon is straight. Some levels have a hot shoe adapter that can be inserted in the camera's hot shoe. Hot shoes are the small brackets located on top of many DSLRs, video cameras and some point-and-shoot cameras. They are normally reserved for on-camera flash or continuous lighting units [w8.5]. By keeping things level, portraits and landscape images will be easier to process later on.

One of the best uses for a tripod is to set up a scene much like the director of a film would. First prefocus using manual focus (or use autofocus if your camera has no manual focus option), and then stand next to the camera as you watch the action through your eyes instead of having to constantly look through the viewfinder or LCD display. Tip 78 has more suggestions for helping keep things tack-sharp.

Shown here (left) is a Bogen/Manfrotto 3265 Grip Action Ball Head. On the right is a Canon DSLR with a matching quick release plate in the camera's tripod socket. Circled in red is a built-in bubble level, and circled in green is an adjustable "locating pin" that allows you to keep the quick release plate in more securely on cameras that accommodate it. It can be unscrewed until it does not show for cameras that have no locating pin socket. In the center of the quick release plate you can see a small handle that flips down to allow tightening the plate to the camera without having to use a coin (like many other quick release plates).

photo © Andrew Darlow

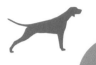

Tip #76

Use a large softbox, umbrella, or a reflector with a flash or continuous light for effective lighting

A large softbox, umbrella, or reflector (about 2 × 3 feet—61 × 91cm—or larger) with either a flash head or continuous-lighting fixture inside can produce a beautiful soft light, similar to diffused window light. Alternatively, a large disc reflector (about 24–50 inches—61–127cm—in diameter) can be placed in front of a small flash unit such as those made by Canon, Nikon, Sigma, or Vivitar to produce a similar light [w8.6]. Alternatively, a photo umbrella can be placed in front of the subject and light can be reflected into it to produce a very attractive light, usually with very distinctive-looking catch lights due to the metal weblike construction of most umbrellas.

There are hundreds of lighting units available. I've put together a list of some popular brands and accessories on the book's companion Web site [w8.7]. Another quick tip to remember is that many on-camera accessory flash units often have an autofocus assist light that can help you focus faster in just about any lighting condition.

The distance you place the softbox, umbrella, or translucent reflector from your subjects will affect the following:

- How hard or soft the shadows are. The closer you move the softbox to your subject, the softer the shadows will be. Depending on what height and angle you choose (side lighting, or light placed directly in front of your subjects), the look of the light and shadows will be very different.
- How wide the coverage of the light will be.
- The size and shape of the catch lights. You can use tape to create the look of a window by putting a few pieces in a tic-tac-toe pattern over a softbox. You can also place a black circular mask over a square light box (or make one with gaffer tape) if you want the catch lights to be round [w8.8].

I photographed this distinguished-looking feline at a client's home at about in 3 P.M. in April. The cat was resting on a rug, so I decided to use a very simple but effective lighting technique. I placed a 40-inch-diameter (102-cm) Lasolite All In One Umbrella (camera right, and fitted with its white insert) on the ground about 4 feet (120cm) from the cat and used a Nikon SB-900 Speedlite unit off-camera, aimed toward the umbrella to create the not-too-hard, yet not-too-soft, lighting. The low perspective offers a very interesting view of the cat, rug, and background. Had I moved the light closer, the shadows would have been a bit softer.

141

"Did you catch last night's Animal Planet special?"

Camera: **Nikon D300;**
Lens/Focal Length: **Nikkor 24–70mm/24mm;**
ISO: **640;** *Aperture:* **f/13;**
Shutter Speed: **¹⁄₁₂₅ sec.**

photo © Andrew Darlow

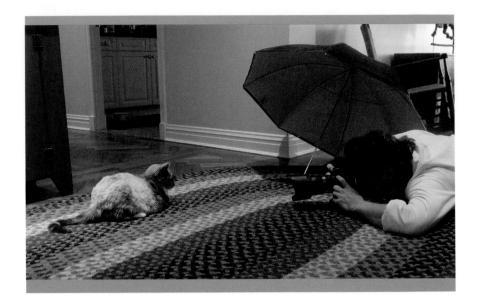

 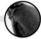

That's me on the floor directing the supermodel. The lens shade helped to increase contrast in the image and reduced the chance of flare from the light hitting the lens. A "gobo" or some light-blocking material could have been placed between my lens and the flash unit, and it would have done the same thing. However, that would have made it difficult for me to adjust the flash unit from shot to shot as I reviewed the images on the camera's LCD.

photo by Paul Kessel

Tip #77
Determine What Flash Mode to Choose on Your Camera

As discussed in Chapter 1, Tip 5, many point-and-shoot and DSLR cameras have shooting modes to help you make better photos in low-light situations. One that is particularly helpful is called slow sync flash mode. On some cameras, it is called night scene or night portrait mode [w8.9]. The icons generally have a star or a moon in them, but they vary from camera to camera, so check your manual.

When you use night scene or night portrait mode, the camera will fire the flash, but will keep the shutter open for longer than it would if you set it to auto mode. This longer exposure time will allow for some ambient light from the background of a city or room to be captured, which usually results in more natural-looking flash exposures. However, it is important to hold the camera steady or place it on a tripod so that your backgrounds are not blurred. The photo in Tip 80 is an example of this technique, but I photographed it using my camera's manual mode and an off-camera flash. Shutter priority mode is another good option for these types of situations because it allows you to choose how long the shutter will stay open. Mixing that with flash can be tricky, but today's Through The Lens (TTL) flash systems make it much easier. In Chapter 3, Tip 23, I discussed fill flash, which is another way to improve your photos, as well as your overall creative options.

Some cameras also have a long-exposure noise-reduction mode. The disadvantage is that the noise-reduction process sometimes can take the same amount of time as the actual exposure because it employs what's known as "dark frame subtraction." For this technique (and for most long-exposure photography), you should also have the camera on a tripod for best results [w8.10].

I took this picture (p. 145) of a distinguished-looking white cat in Kyoto, Japan, one evening in 1990 when I was out with friends. I used a 35mm point-and-shoot film camera with no special settings, and because of that, the background is quite dark, because when the flash fired, the camera chose a very short shutter speed (probably about $\frac{1}{100}$ sec). Even so, I like the way the cat stands out in

the scene, and I show this image because sometimes a dark background, when shot with flash, will look fine. By learning how to make some adjustments to your camera using a night, shutter priority, or manual mode, you can control the way your lighting will look, instead of just leaving it up to your camera.

144

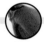

"Know any good sushi places around here?"

Camera: Minolta Freedom Zoom 90 (35mm);
Film: Fuji Color Negative;
Lens/Focal Length: Fixed-zoom 38–90mm;
Aperture, Shutter Speed, and ISO: unrecorded.

photo © Andrew Darlow

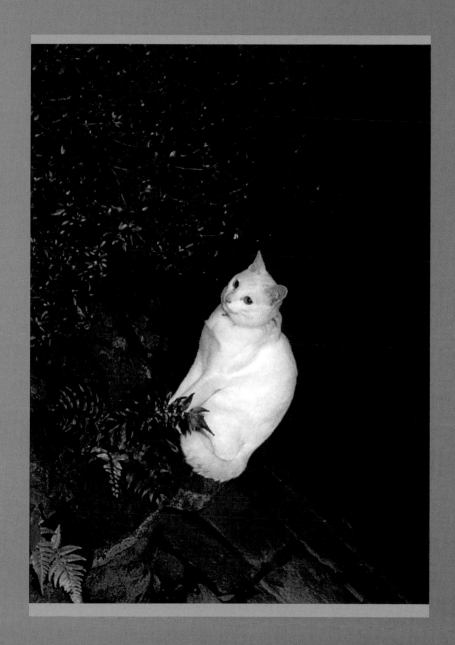

Tip #78
Use a Cable Release, Self-Timer, or Mirror Lockup Mode

A wired or wireless cable release allows you to keep your hands off the camera during an exposure, which can help to reduce movement during a shot when your camera is on a tripod or a stable surface. A self-timer is often more convenient to use, but it's not nearly as easy to get a shot at a specific moment in time. Some cameras have a timer option that's just a few seconds (instead of 8–12 seconds), which is very helpful if you are right next to your camera. Just depress the shutter gently, and in a few seconds, the shutter will fire.

Mirror lockup is a feature available on many DSLRs. By engaging mirror lockup (often through a custom menu), you can reduce vibrations inside the camera because the mirror does not have to flip out of the way to expose the film or sensor. This can result in sharper images when you have the camera on a tripod. I have seen a subtle but discernable difference when using mirror lockup on various cameras. This tip is primarily for those who are doing macro or other detailed work [w8.11].

Just remember that on most cameras, the first press of the shutter release (or cable release) will engage the mirror lockup and the second press will make the actual exposure. It's also a good idea to wait 2–5 seconds after engaging the mirror lockup before making your exposure to allow for vibrations to be reduced.

Tip #79

Reduce or Eliminate Red Eye with a Few Techniques

Red eye (or green/purple/blue eye, as is the case with many pets) can be very distracting in photographs. This problem is usually caused when photos are taken with a flash in a dark environment, and the issue can be avoided or greatly reduced with some of the following techniques:

- Turn off the flash and use some of the shooting and lighting techniques described in Tip 73.
- Separate the flash from the camera lens by at least 6 inches. This is usually only possible with more advanced cameras, such as DSLRs. Moving the flash unit off-camera is the best option.
- Use a red-eye reduction feature. This approach is often not very effective, and it can scare your pets if it uses an approach that uses multiple flashes of light. The preflash red eye–reduction mode is also famous for tricking people into thinking the photo has already been taken, so you may end up with closed eyes or expressions that you don't want.
- Have your subjects look into a relatively bright light for a few seconds before taking the photo. This may be difficult for dogs or cats to do, so if you quickly illuminate the whole room for a few seconds, then turn off the lights, this technique can help.
- Fix the red eye in a software application (many can do this effectively). This is definitely a solution, but it should be your last option [w8.12].

(a) Shown here is the Custom Timer menu for the Canon PowerShot SD790 digital camera. Many other cameras have similar features. It also controls single shot mode (shown as a single rectangle), or high speed continuous shooting, which will allow you to take multiple photos with a single press of the shutter button (shown as three stacked rectangles). Next is a 10 second self timer, then a 2 second self timer (great for when you have the camera on a tripod bean bag, etc. without a cable release). Last is a custom timer option, which, when selected, brings up the menu to the right (b). In that menu, the number of seconds (0–10 seconds, 15, 20 or 30 seconds in the case of this camera) and the number of continuous shots to be fired, can be set. If the flash is used in this mode, the camera will wait to shoot until the flash recycles.

photo © Andrew Darlow

Tip #80

Use a wireless flash trigger both for safety and to expand your lighting options.

Wireless flash triggers enable you to fire a flash from your camera without any wires between them. That's a much safer option compared with having wires between your camera and an external flash. Wireless triggers are available in numerous types, shapes, sizes, and price points [w8.13]. They can be used with just about any camera that has either a hot shoe or a PC terminal, but an inexpensive adapter is needed if your camera has a hot shoe but no PC terminal [w8.14]. The PC terminal has traditionally been used to connect a studio flash directly with a wired sync cord, but it can be used to plug in a wireless flash trigger.

Some cameras include built-in wireless functionality for their own company's flash units. For example, the Nikon SB-600 and SB-800 Speedlites can be triggered wirelessly by the Nikon D70, D200, D300, and other Nikon DSLRs with no additional equipment [w8.15]. Some camera manufacturers sell transmitters that attach to the camera's hot shoe that can fire flash units wirelessly. An example is the Canon ST-E2 Speedlite Transmitter for Canon 580EX II, 430EX, and 430EX II Speedlites [w8.16]. Like many accessory flash units, the ST-E2 can also improve autofocus in almost any light.

Other options for firing flash units wirelessly include built-in or accessory optical photo cells on flash units. These photo cells (a.k.a. optical slaves) can sense other flashes, and when they detect them, they fire as well [w8.17]. The main problem with these is that if anyone else has a camera in the area that flashes, it very well may trip the flash that has the photo cell enabled.

For this photo of a woman and her Soft Coated Wheaton Terrier, photographed at about 10 P.M. in June on a building in New York City, I used a Quantum Radio Slave 4 wireless transmitter and receiver. The camera was about 15 feet from the flash, and the flash unit (Vivitar 285HV) was diffused using a LumiQuest Big-Bounce accessory placed on a stand about 10 feet from the sub-

jects (camera left) [w8.18]. The shadows falling on the woman's face were lightened a bit, and selective sharpening was done to draw more attention to their faces, as well as the woman's hair and scarf.

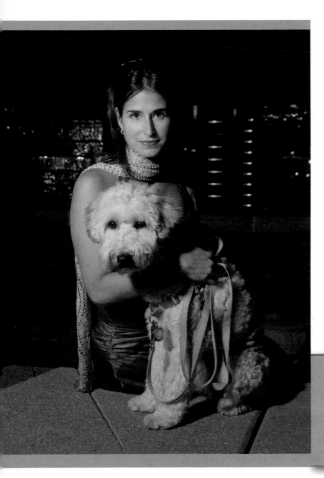

"I hope Craft Service has the Milk Bones again tonight."

Camera: Canon EOS-20D;
Lens/Focal Length: Tamron
18–200mm Di II/38mm;
ISO: 800; *Aperture:* f/7.1;
Shutter Speed: $\frac{1}{13}$ sec;
photo © Andrew Darlow

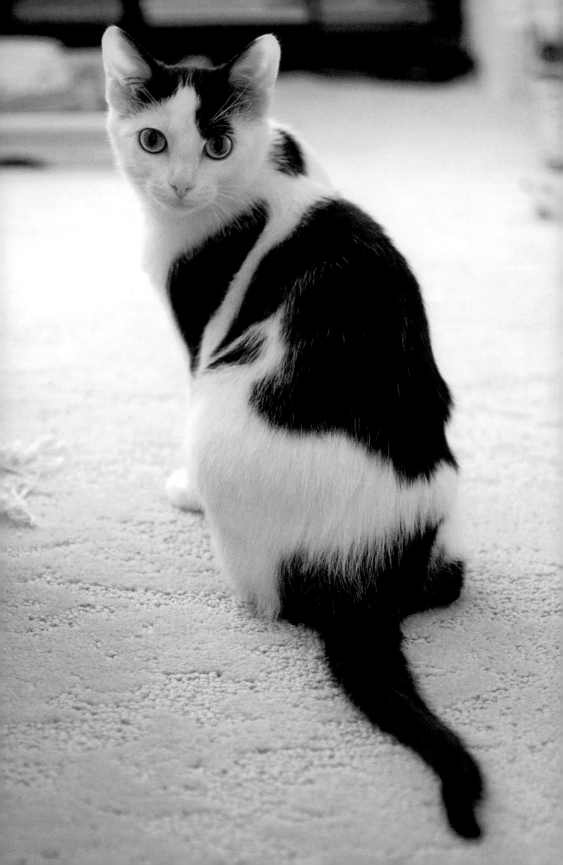

9

The Digital Canine and Feline: Technical Tips and Printing Advice

"Digital" and "photography" are two words that go together like cats and sleep. Digital Photography encompasses many topics, including: using a digital camera to capture and display images; shooting with a film camera and then scanning the originals; retouching images on a computer regardless of where they originated; printing final works of art on a printer of some type; and outputting new film or paper on a device and using it to make prints with traditional methods (for example, outputting new negatives to make photo prints in a dark-room). In this chapter I will cover tips related to the wide world of digital photography, presented in the following order:

1. Organization and imaging software options;
2. Scanning and retouching;
3. Black-and-white photography;
4. Printing.

Please note: When you see notations like *[w9.1]*, it means that a related Web link (and usually additional information) can be found by visiting the book's companion Web site at *www.PhotoPetTips.com*.

Photo on facing page © Andrew Darlow [see Tip 98 for image information]

Tip #81

Back Up Your Digital Files in Multiples!

152

This is the first tip in this chapter because it is so important. Digital images can easily be lost if a laptop is dropped, if a hard drive stops working, or if a CD or DVD on which you have your photos stored just goes bad. And the possibility always exists of fire, flood, or other damage. In addition to keeping one copy on your working computer for a while, back up your photos to at least two external devices (for example, a hard drive and DVD) and keep one of them separate from the other (preferably in a different town or city). You will have both piece of mind, and a better chance of not losing any of your life's memories and/or assignments (if you are a professional photographer). Another option for a third backup would be to use an online backup service (many are very affordable and some are free) or a shared or dedicated server that you manage yourself. Some backup services, as well as a number of books and other resources that discuss both backing up and overall digital asset management can be found on the companion Web site [w9.1].

Caption: The screen shot above from mozy.com highlights the company's Mac- or Windows- compatible online backup services, including a non-business backup plan for under $5 per month.

Tip #82

Store Your Cards Properly and Reformat Them in the Camera

This tip covers two important things: making sure your cards are stored properly in a card case or bag so that you know their current status, and making sure that you prepare your card properly for shooting after downloading. In the days of film, it was easy to know which rolls were new and which were exposed. That's not the case with removable media cards like SD/SDHC and CompactFlash cards. One good way to let you know that you've already filled a card is to turn it over and put it in a separate place from the cards that you haven't used yet (I learned that from Vincent Versace when I viewed the online Epson Print Academy). All cards I've seen have one side that has a company name, and another side that has a black-and-white label (or it is blank).

There are many media card cases available, and I use a few types. In the photo on the following page, you can see two of the card cases I use with "new" cards (ready to be shot with) on the left, and cards that have been shot but not yet downloaded on the right.

After downloading and backing up your files to a computer, and after reinserting a card back into your camera, you should always reformat your card in the camera (not the computer). Virtually every digital camera has a card format option accessible through its menu, though you may not find the option on some cell phones. In those cases, consult the manual, or ask the manufacturer how to properly erase or reformat a card's data.

Some media cards (including SD/SDHC cards) have a "Lock" function that can be enabled after you've filled a card, or any time you want to keep data from being written to or from the card. This approach can be used in conjunction with the tip above (turning over the card) for a second level of protection. For SD/SDHC cards, to enable the lock function, just slide the small plastic switch down. You will need to move the switch up to copy data from the card to a computer or other device, and of course, you'll need to move the switch up before you reformat the card in the camera and start shooting again.

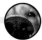

These two media card cases were promotional items given out at various photo trade shows. You can find many inexpensive card carrying cases at photo retailers [w9.2].

photo © Andrew Darlow

Tip #83

Manage your cards and files properly from the beginning with a date-based system

Many people just copy a folder full of images from their media cards to their desktop and leave it there until their hard drive is filled, but that's not a very good choice. There are some very basic approaches to organizing your media cards and images that will help you to take control of where things are stored, and how they are archived. Also consider that at some point, you will need to make room for new photos on your computer. Having a good system in place will help make that possible with little risk of losing precious images later on.

The main suggestion I have to help reduce the problem of losing images is to create folders for your image files organized by date. Though not complex, describing the process takes a considerable amount of space, so I've written an extensive, step-by-step article on this process that you can find on the companion Web site [w9.3]. This is the system I use, and the system that I've set up for many of my consulting clients. I've also created a zip file with a set of named and organized folders (for Mac or Windows), ready for you to begin using to help you organize your new images as well as your archives [w9.4].

This screenshot illustrates from left to right how the folder structure might look for the date-based system described in the article on the companion site. You may want to add, remove, or rename the folders depending on the type of work you do.

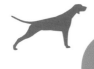

Tip #84

Rename your image files to avoid overwriting files

Most digital cameras produce file names with four-digit numbers, and you generally have two choices: the camera's counter will keep counting up and then start over after you've taken 9,999 pictures (known as Continuous or Sequential File Numbering), or it will reset when you insert a newly formatted media card (known as "Auto Reset"). For example, IMG_1234.CR2 might be a RAW file name that the camera would produce. The problem is that if files with the same names are used in any asset management system, it can lead to problems, including possible deletion of files, because you may think that the files are duplicates. Believe me when I say you want to avoid this problem!

Some cameras add a random string of text to the beginning of every file on every new card that you format, which should solve the problem, but this is rare. Instead, after downloading your images, I recommend renaming your files in one of many applications that have the capability. I often use Adobe Bridge, which comes with Adobe Photoshop. Adobe Photoshop Elements also has this capability. Links to file renaming tutorials can be found on the companion Web site [w9.5].

When renaming, I recommend choosing the capture date followed by a "_" (Key command: Shift plus the minus key) and the original file name. That way the application will read the metadata of the file, see when it was shot, and put that date in the beginning of the file name. You will then know, while browsing through your images, exactly when the photos were taken. The result can look something like this (with my preferred date format, YYYYMMDD): "20091125_IMG_1234.CR2." That means that the image was captured on 11/25/2009. Some applications even allow you to search for text and remove it during the file renaming. For example, you could have the "IMG_" removed so that your file becomes "20101224_1234.CR2." Regardless how you rename your files, don't use any spaces or special characters. Keep it to letters, numbers and underscores like the one used in our example.

Tip #85

Find the right software options and learning tools for working on digital files

There are many alternatives for processing and retouching your digital files, starting from free options that come with computers such as Apple's iPhoto (comes with all Apple Macs), to inexpensive but powerful options like Adobe Photoshop Elements and Corel Paint Shop Pro. Another free option to consider if you use a Windows computer and shoot in JPEG is Picasa. Though Picasa will view and process RAW files from some cameras, I recommend other applications in Tip 86 for processing RAW files. Some online printing services, like Shutterfly.com and Snapfish.com, offer a fair number of image editing options to help you edit your photos for online galleries, books, cards, prints, etc. without the need for any additional software.

Of course, Adobe Photoshop is the "big dog" when it comes to software used for retouching image files. And for good reason—it's an extremely powerful tool and there are a tremendous amount of learning tools available for it for free and for a fee through online video- and DVD-based learning programs like those offered at Lynda.com, PhotoshopUser.com, Kelbytraining.com, Software-Cinema.com, and TotalTraining.com. Many of these companies offer excerpts of some or all of their tutorials for free so that you can sample the quality and content. A list of links to these and other Adobe Photoshop resources can be found on the companion Web site [w9.6].

If you are not ready to invest in Adobe Photoshop but would like to start learning the program so that you are better prepared should you want to upgrade, Photoshop Elements shares many of the key commands, layer controls, and other features of the full version of Adobe Photoshop. In addition, Photoshop Elements offers an incredible array of features including slide shows with fantastic effects (including the ability to make a DVD with images and music), downloadable scrapbook pages, calendars, and book templates. You can even order cards with your images embedded, design photo books, and send away for photo prints all from inside the application.

(a)

(b)

(c) http://www.software-cinema.com/training/adobe-photoshop/eddie-tapp/59/create-it-fix-it-mask-it-finish-it-in-photoshop-cs4

Screenshots of three popular fee-based training options that offer training both online and through DVDs (Lynda.com, Kelbytraining.com, and Software-Cinema. com). Each one covers Adobe Photoshop extensively, and I recommend checking out their offerings for many other applications.

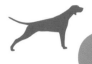

Tip #86

Consider a RAW Processing and Workflow Application

160

This tip is related to Tip 85 but deserves its own space because applications that can be used for RAW file processing and general file organization (a.k.a. asset management) have come a long way in a short time. These applications include Adobe Photoshop Lightroom, Apple Aperture, and Adobe Camera Raw (comes bundled with Adobe Photoshop). Lightroom and Aperture both have trial versions available for download, and both have many free and fee-based tutorials available. Adobe Camera Raw is an excellent RAW processing application, but it does not allow for extensive photo organization of files that are located both on and off your computer as Lightroom or Aperture do. One important item to realize is that Lightroom is available for both Mac and Windows, and Aperture is available only for Macs.

As I did in Chapter 1 when describing different cameras, I've written a lengthy article on the companion Web site covering many of the advantages of using either Lightroom or Aperture. Each program also has unique features that are discussed in the article and on other Web sites [9.7].

The Lightroom Library interface is shown here, with the metadata search filter feature enabled. As you can see, you can select from many different criteria, including lens, labels, or capture date. The photos in this specific folder are offline so they show a question mark next to each icon. That allows me to still search the thumbnails, and when I want to access the high-resolution files, I can just attach the hard drive where the images are stored. In some cases, re-linking files is necessary, which is described in this article on the companion Web site [w9.8].

Photos in Library © Andrew Darlow

Tip #87

Size down the files you send via email and consider the zip file format

As megapixel counts get higher on point-and-shoot cameras (and even some camera phones), it is more difficult for people to open large files. Even if you shoot JPEG and think that the files are not too big (maybe 2–3 megabytes (MB) each), when the recipient of your photo tries to open the file, they could be 20–30 MB in size in their uncompressed form! There are a few ways to deal with this. First, don't send RAW files (most people can't open them—especially through an e-mail application); instead, batch process them in a RAW processing application. A good size to choose for processing is 800 pixels on the long side with medium- to high-quality JPEG compression. That will result in files of about 80–200 k (kilobytes). Also be sure to embed the sRGB profile, which will be an option inside the RAW processing application. If you use AdobeRGB, your colors will probably not look good on the recipient's monitor.

Another option for Apple Mail users (comes free with all Macs) is to just drop your camera's JPEG files into a body of a new Apple Mail message, then choose small, medium, or large from the bottom right of the message window where it reads "Image Size." The Mail application will then resize your images for you and on the left side you will see the size of the message. Other email applications may have a similar feature. However, don't try to resize a PDF file in this way—it will get corrupted, and you won't be able to be open it.

This Apple Mail message shows an image about to be emailed with the window that allows you to size down the compatible files (such as JPEGs) selected. Note the file size readout on the left side.

Photos in email message © Andrew Darlow

The zip file format allows you to compress one or more files of just about any file type and send them via email or through an FTP server with little chance of them getting corrupted. The best way to make a zip archive is to make a new folder with a name like "PhotoArchive01," then create the zip archive using your computer. Macs have a built-in way to do this by right-clicking or Ctrl-clicking on the folder and choosing "Create Archive of ...". Most Windows Vista computers also allow you to make a zip archive by right-clicking on a file or folder then choosing "Send to: Compressed (ZIP) Folder." Otherwise, some Windows applications are available including WinZip that will create zip files. To uncompress a zip file, just double-click on it. Of course, make sure that you know the sender before clicking on any file that you receive. A number of free services for sending files are also available. One that I've used successfully is sendthisfile.com

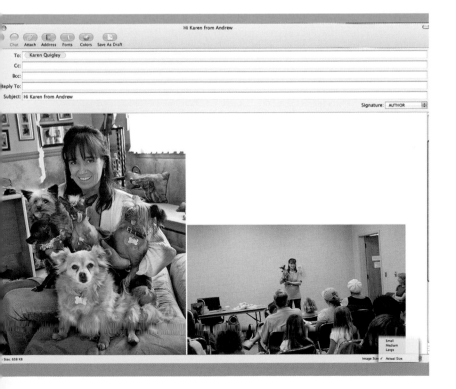

Tip #88

Use online galleries and animated slideshows to present your images

Sending files via e-mail works well, but for security reasons, many companies restrict e-mail with attachments. Also, e-mail attachments take time to download, and too large an attachment can cause someone's e-mail inbox to fill up (a sure-fire way to get someone upset!). Instead, it's generally better to create a Web gallery or animated slide show and just send a Web link to the gallery or slide show to your friend or loved one. Below are a few options for creating a Web gallery or Slide Show:

- Use an online photo lab/printing company. This option is often free, and the companies who offer this service include Shutterfly, Snapfish and Kodak Gallery. Check each one to see which one works best for you before uploading hundreds of pictures. Also make sure that you don't make your images available for viewing to the general public (unless you want to). Each company handles the sharing/security of galleries, books, etc. differently, and in some cases, the number of images (or total file size) is limited. Once you are ready to share your gallery and/or slideshow, most providers make it easy for you to send an invitation directly from the Website to your contacts. Because of the high incidence of e-mail phishing schemes, you may want to let your family and friends know ahead of time that they will be receiving a link from the online lab.

- Use an application that has built-in tools for creating an online gallery and/or animated slide show. There are many, many software options on the market that can be used for these purposes. A list of many of them, including links to tutorials, can be found on the companion Web site [w9.9].

Tip #89

Get your old negatives, slides, and prints scanned (or scan them yourself)

Most people have decades of negatives, slides, and/or prints in shoeboxes, albums, slide carousels, and frames. Wouldn't it be great to have your favorite photos from the past available in digital format, both to have as an archive, and to be able to share with family and friends via email, online galleries, and through digital prints? Understandably, it can be a daunting task to choose which photos you might want to scan from hundreds or thousands (especially if they are in negative form).

165

This is another topic that is very broad in scope, with many options. To best describe some of the many ways in which you can bring your archives into the 21st century, I've written an extensive article on the topic on the companion Web site. It includes scanning options for do-it-yourselfers, as well as companies who scan prints, negatives, and/or slides [w9.10].

I photographed the poodle on the following page Hasedera Temple in Nara, Japan, with a point-and-shoot camera on a beautiful spring day in the early afternoon when the flowers were in full bloom. The digital file was produced by a drum scanner from a small 4 × 6-inch (10 × 15-cm) color glossy print. A scan from the original negative would have resulted in a file with more detail, but this image looked fine even when printed up to about 16 × 20 inches (41 × 51 cm).

Screen shot from a popular scanning service company– ScanCafe Inc. (www.scancafe.com).

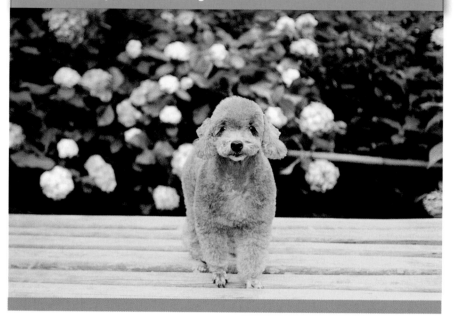

"If this background's too busy, I know a great spot nearby."

Camera: Minolta Freedom Zoom 90 (35mm);

Film: Color Negative;

Lens/Focal Length: Fixed-zoom 38–90mm;

Aperture, Shutter Speed, and ISO: unrecorded.

Lighting Notes: The lighting for this image is coming entirely from natural light, and the bench that the dog is standing on is providing some fill light.

photo © Andrew Darlow

Tip #90

Adjust color temperature settings quickly with the help of gray cards

I covered the camera portion of this tip in Chapter 1, Tip 4. Assuming you have a captured digital photo or scanned photo with a gray card or other product designed for gray balancing in the scene, you can use the gray-balance tool in almost any imaging application to click on the gray area so that the software knows what should be neutral. In a perfect world, once you do that, all the other colors will fall into line and you won't need to make any additional color adjustments. Of course, the world is not perfect, so you may need to make some adjustments to either the white balance, "tint" slider (if available), or other color adjustment options once you set the white balance.

One good option is to use a photo editor that is nondestructive, like Apple Aperture or Adobe Photoshop Lightroom, even if you shoot entirely in JPEG mode, because you can make changes to the white balance settings regardless of the file type. However, RAW files will retain better overall quality compared with JPEGs when making white balance adjustments. Once you make adjustments to one image, you can quickly apply the same adjustments to many other images if your imaging application has the feature, such as Aperture, Lightroom, and Adobe Camera Raw.

In some applications, including Photoshop Elements, you can use a curves or levels adjustment layer to set a neutral color by sampling the neutral gray card with the midpoint eyedropper. Once you've made those color adjustments, you can then drag and drop the adjustment layer to other images photographed under the same lighting to achieve a similar result in other pictures [w9.11].

Tip #91

Use proper color management and select sRGB or AdobeRGB from your camera menu

The whole topic of color management can seem overwhelming. The key to understanding and using color management is to first understand that all devices, including your camera, monitor, and printer/paper combinations, have a certain number of colors, known as the color gamut, that they can capture, display, or print.

Dealing with the differences in gamut between devices is a big part of color matching and proper printmaking. By making custom profiles for our monitors and specific printer/paper combinations, we can help to come closer in color between the different devices. Also, it's important to note that every device must operate consistently and in a stable environment for color management to work properly. If one day you are working outside on a laptop in the bright sun, and the next day you are in near darkness, you are not viewing your screen in a consistent environment, and you probably won't get the results you want.

A common question that comes up often is whether people should set their camera to the sRGB or AdobeRGB working space (an option on all DSLR and some point-and-shoot cameras). AdobeRGB has a wider gamut than sRGB, so if a printer and paper combination has a very wide gamut, and your picture has very bright colors, you should be able to print more possible colors from images if you have the AdobeRGB working space profile embedded and use proper color management. For those who shoot RAW files, it really doesn't matter what you set your camera to because you will determine your file's working space when you export the files. If you shoot only in JPEG or TIFF, then it is important, and for most people, I'd recommend sRGB if you don't want to have to convert the files to sRGB to have them printed at a photo lab or when posting them online. However, there is a good argument for using AdobeRGB even if you only shoot JPEGs because of the additional colors that you can retain in your file (especially if you plan to make prints using inkjet printers). Also, if you shoot only JPEG or TIFF with sRGB embedded and then

convert to AdobeRGB, you won't get back the bright saturated colors you've already lost.

As I mentioned, most photo labs expect incoming files to be converted to sRGB. You can convert all lab-bound files to sRGB in Adobe Photoshop or Photoshop Elements by choosing "Edit > Convert to Profile > sRGB." Other applications also have this capability. In Lightroom, Aperture, or another color management–aware application, choose sRGB when exporting.

169

There are countless articles and many books available on the topic of color management, including reviews of and information regarding different monitor and printer calibration and profiling hardware and software options, the importance of lighting, as well as related topics like whether to retouch and print in 16-bit versus 8-bit color mode [w9.12].

On the topic of lighting, few things are as important as understanding and controlling lighting at all times. Pictured below are a few excellent products from SoLux. I often use SoLux Clip-On Fixtures during my workshops to explain color temperature and lighting options for display or proofing. Proofing essentially means checking your work, and if you don't use a consistent lighting system (including having consistent lighting in the room where you are working), you will have a difficult time achieving proper color management.

(a) The original SoLux Task Lamp shown in three configurations. All ship with a SoLux MR-16 bulb. (b) Two SoLux MR-16 halogen bulbs are shown here. The top bulb is called the Solux "Black Back." Its design eliminates light leakage from the back.

photos courtesy Tailored Lighting, Inc.

Tip #92

Check your image quickly
and effectively for dust,
dirt, etc.

If you've ever scanned your own prints, negatives, or slides (or had a lab scan them without dusting them for you), you've probably had some experience with the clone tool. That's because almost any scanned image will have dust, hair, and other unwanted stuff on your images. There are a number of ways to handle this issue, including using a dust and scratch removal tool, such as the Dust and Scratches filter found in Adobe Photoshop and Photoshop Elements. A few tutorials that cover dust removal can be found on the book's companion Web site [9.13].

Regardless of what tools you use, you'll need to check your image effectively. The way that I've been doing that for years is to first fill the screen with your image, then zoom to 50, 66.7, 100, or 200 percent in your imaging application depending on the resolution, how detailed the image is, and how large you plan to display or print the file. (Note that 50, 100, and 200 percent are also known as 1:2, 1:1, and 2:1, respectively, in Lightroom and some other applications.) Then, starting at the top left work from top to bottom, inspecting the whole section of the image that you see in that area. Using the space bar in Adobe Photoshop and Photoshop Elements, you can turn the mouse into a hand and quickly move down to the bottom as you clean up the file. When you reach the bottom, move the image to the left using the space bar so that a new section is visible. Then continue moving up and cleaning the image until you reach the top. Then repeat this process until you're done. I then recommend taking one quick look again using the same technique at either the same zoom level or one zoom level closer.

Tip #93

Sharpen with care (sometimes selectively) depending on the subject

Sharpening is a critical step whether you are preparing files for display on a large computer screen, DVD presentation, Web page, printed brochure, or fine art print. Properly sharpened images will look much better than over- or undersharpened photos. Though it may seem simple, this is a huge topic with many options, and the article links provided should help you to better determine which options to consider, and which options to try. For example, in one article that I've written on the topic (demonstrated in the photo of Elwood seen here), I describe how blurring parts of the photo can create the appearance of increased sharpness in an image [w9.14].

171

In this photo of Elwood in a "hero pose," I selectively blurred the background and his right ear, and sharpened his eyes a bit more than the other areas of his face to draw more attention toward his eyes.

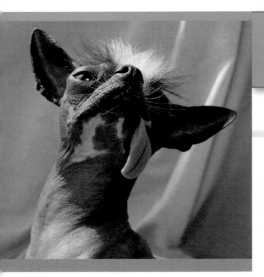

"I wonder who Mommy will bring home next for us to play with?"

 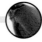

Camera: Canon EOS-5D;
Lens/Focal Length: Canon 50mm;
ISO: 320; *Aperture:* f/11;
Shutter Speed: $\frac{1}{125}$ sec;
Lighting Notes: Lighting came primarily from a single off-camera diffused flash, placed slightly camera left. Natural daylight from a few windows located on the left provided some fill light, and much of the light for the background.

photo © Andrew Darlow

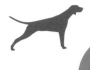

Tip #94

Choose an appropriate resolution depending on your output

The question of what resolution, or how many pixels per inch (ppi), your files should be at their final print size is a common question. I always recommend testing to see what works for your images. I print most of my work around 200–300 ppi at final size to inkjet printers and continuous tone photo machines (like those found at professional labs). However, 150–200 ppi or even lower has also worked well for me in many cases, especially when making larger prints. Your file's image quality, plus the paper, printer, amount of sharpening, and final output size, will all contribute to the final quality of your prints.

You can check just about any file size quickly in a variety of imaging programs. For example, you can choose "File > New" in Adobe Photoshop or Photoshop Elements. Then enter the dimensions, ppi, and color mode (for example, grayscale, RGB, 8-bit or 16-bit, etc.) and you will see your file size in megabytes appear at the top of the box.

File Dimensions (below)	100PPI	150PPI	200PPI	230PPI	269PPI	320PPI	400PPI	650PPI	RES 30 762PPI	RES 40 1016PPI	RES 50 1270PPI	RES 80 2032PPI
35mm (24mmx35mm)	40k	89k	157k	208k	284k	402k	628k	1.815	2.49	4.4325	6.9225	17.7
6cm x 4.5cm	123k	276k	490k	648k	870k	1.23	1.92	5.0625	6.9525	12.375	19.35	49.425
6cm x 6cm (2.25" sq.)	164k	368k	653k	847.5k	1.1625	1.635	2.5575	6.7425	9.3	16.5	25.725	65.925
6cm x 7cm	191k	429k	762k	982.5k	1.3575	1.905	2.9775	7.875	10.8	19.2	30.075	76.875
6cm x 9cm	245k	551k	960k	1.2675	1.7475	2.4525	3.8325	10.125	13.875	24.75	38.625	98.85
4" x 5"	586k	1.29	2.2875	3.03	4.17	5.8575	9.15	24.15	33.225	59.1	92.325	236.25
5" x 7"	1.005	2.25	4.005	5.295	7.2975	10.275	16.05	42.3	58.125	103.35	161.55	413.475
8" x 10"	2.2875	5.1525	9.15	12.075	16.725	23.475	36.6	96.675	132.9	236.25	369.15	945.075
8.5" x 11"	2.6775	6.0225	10.725	14.175	19.5	27.375	42.825	113.025	155.325	276.15	431.475	1104.525
11" x 14"	4.41	9.9	17.625	23.325	32.1	45.15	70.5	186.15	255.825	454.8	710.625	NA
11" x 17"	5.3475	12.075	21.375	28.275	39	54.825	85.575	226.05	310.65	552.3	862.95	NA
14" x 18"	7.2075	16.2	28.875	38.175	52.575	73.8	115.35	304.65	418.65	744.225	#######	NA
16" x 20"	9.15	20.625	36.6	48.45	66.75	93.75	146.475	386.85	531.6	945.075	#######	NA
20" x 24"	13.725	30.9	54.9	72.675	100.125	140.625	219.75	580.2	797.4	#######	NA	NA
24" x 30"	20.625	46.35	82.425	108.975	150.15	210.975	329.625	870.3	1196.1	NA	NA	NA
30" x 40"	34.35	77.25	137.325	181.65	250.275	351.6	549.3	#######	NA	NA	NA	NA
36" x 48"	49.425	111.225	197.775	261.525	360.375	506.25	NA	NA	NA	NA	NA	NA
40" x 60"	68.7	154.5	274.65	363.225	500.55	703.125	NA	NA	NA	NA	NA	NA
48" x 96"	131.85	296.625	527.325	697.425	961.125	NA	NA	NA	NA	NA	NA	NA

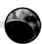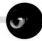

A downloadable PDF of this resolution chart is available on the book's companion Web site [w9.15].

Resolution chart © Andrew Darlow

Tip #95

Borrow from multiple images to expand highlight/shadow detail or for other creative uses, including HDR photography

173

One of the most powerful ways to improve your images is by expanding the dynamic range of your photos by combining multiple photos. To do that, you can process the same file twice (once for the highlights and once for the shadows). RAW files are much better for doing this because they can usually be adjusted more than JPEGs (less visible artifacts, noise, etc). Then combine the photos in Adobe Photoshop or another application by using masks and "painting" in the area that you want to replace. Even better than processing the same file twice, especially if the file does not have enough highlight or shadow detail, is to use the bracketing techniques described in Chapter 1, Tip 8, to capture multiple images at different exposures (preferably using a tripod so that images will be in perfect registration, which means that they will line up perfectly when placed on top of one another).

On a related note, high-dynamic range (HDR) photography is very popular these days, and you can create very realistic or really wild-looking images with this technique. The approach usually works best when you take pictures of the same image at different exposures in perfect registration. Special software can then be used to expand the dynamic range. And because expanding dynamic range is such a popular topic, there are links to tutorials about combining multiple files as well as HDR photography on the companion Web site [w9.16].

For the image of a client's two dogs on the following page, I used a tripod, and processed the file twice in Adobe Camera Raw. The first file was processed to capture detail in the overall room and for the dogs, and the second was processed for the window. I then combined them in Adobe Photoshop using layers and a layer mask, and painted in the window detail to achieve the look you see.

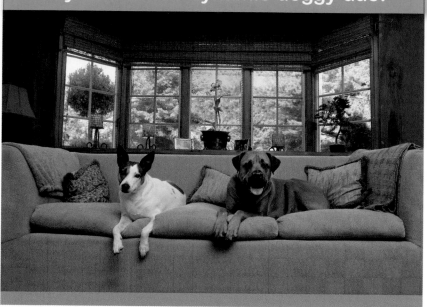

"They call us the dynamic doggy duo!"

Camera: Canon EOS-D60;

Lens/Focal Length: Canon 50mm macro;

ISO: 200; *Aperture:* f/2.8;

Shutter Speed: $\frac{1}{45}$ sec;

Lighting Notes: Lighting for the dogs came from a mix of natural daylight from the windows located behind the dogs, as well as a Vivitar 285HV flash unit with a LumiQuest Big Bounce light modifier on it to soften the light and create some of the catch lights you see in the dogs' eyes.

photo © Andrew Darlow

Tip #96

Experiment with different cropping and vignette options

This is nothing new in the world of photography, but cropping a photo can have a dramatic effect on its overall impact. And virtually every image editor allows you to crop your photos. One great way to determine what cropping might look like is to just zoom into different areas of your image, regardless of what image editor you are using. Once you see something you like, grab the crop tool and crop it. Be sure to first save any edits that you've made up to that point and consider naming the file something that differentiates it from your cropped version.

Vignetting control is another powerful tool found on some image editors. Vignetting (also called "falloff") means a reduction of an image's brightness in or near the corners of an image. It occurs in many photographs due to light falloff from a camera's lens. A number of applications have built-in ways to lighten darkened corners or to create the vignetted look.

One versatile third-party application that has a number of vignette options is PhotoKit, an Automate plug-in toolkit for Adobe Photoshop. The software has a total of 141 effects, and is well worth trying out. PhotoKit-EL is a similar toolkit that is available for some early versions of Photoshop Elements [w9.17].

See Tip 97 next for an example of an image before and after cropping and vignetting. The example is subtle to show how just a few small changes can make an overall difference in the look and feel of a photograph. Other before and after cropping examples can be found in Chapter 5, Tip 40, as well as in the book's Preface–see the section in which I describe the cover photo. And more cropping and vignetting tips and tutorial links can be found on the companion Web site [w9.18].

Tip #97

Create outstanding black-and-white and retro-looking images from your digital files

The look and feel that's possible to achieve with images that are black and white is truly amazing. Dogs and cats can look especially good when transformed into black and white, and it's important to note that black and white is not just about neutral gray images; it encompasses a wide range of toned images, from brown-toned prints with a sepia tone that look like vintage darkroom prints, to cool-toned bluish images that look like hand-coated 19th-century cyanotypes.

Whether you work from a scanned print or slide, or whether you capture an image with a digital camera in its standard color mode, you can produce great-quality black-and-white images using a number of different applications. Adobe Photoshop and Lightroom share a similar and powerful black-and-white adjustment tool that allows you to pinpoint a specific color range and make it lighter or darker throughout the image.

Some plug-ins and standalone applications have been created to help photographers create better black-and-white images from color or existing black-and-white files. These include Alien Skin's Exposure 2 and Nik Software's Silver Efex Pro. They both make it easy to approximate the look of different classic (in some cases, discontinued) film types. Trial versions are available for just about every plug-in and standalone application you can imagine, and links to a number of black-and-white tutorials and software options can be found on the companion Web site [w9.19].

For this photo of a client's cat (originally in color, as shown on the facing page), I used Lightroom's powerful black-and-white conversion tool to convert the image. To do that, I first hovered over the center of the cat's right cheek with the target adjustment tool in grayscale mode and moved the tool up as I pressed the mouse button. That darkened the cheek area as you can see in the final image. I then made some adjustments to the white balance to

lessen some of the noise I noticed. I also used the crop tool in Lightroom and used the Vignette settings shown in the screenshot to illustrate those two features. The vignette settings are provided so that you can see the adjustments before and after processing.

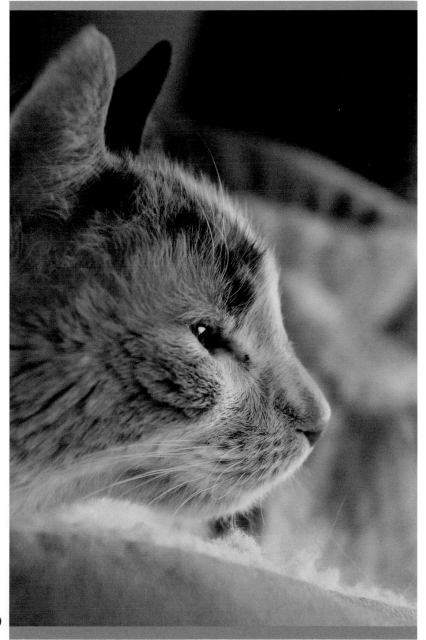

(a)

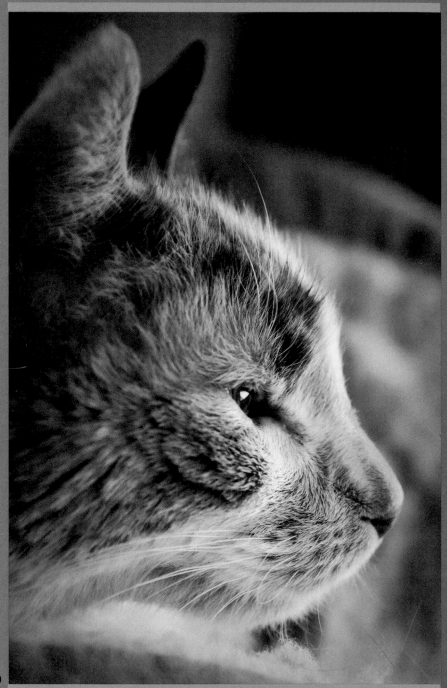

(b)

(c)

(a) The before photo in color prior to cropping and converting to black and white.
(b) The image after cropping, converting to black and white, and applying a
vignette in Lightroom. (c) The vignette adjustments made in Lightroom for the
black and white image to the left.

Camera: Nikon D300;

Lens/Focal Length: Nikkor 24–70mm/70mm;

ISO: 640; *Aperture:* f/5;

Shutter Speed: $\frac{1}{125}$ sec;

Lighting Notes: Lighting came from a combination of daylight from a large window,
as well as a small flash unit (Nikon SB-900) shot into a 40-inch-diameter (102-cm)
Lasolite All In One Umbrella (camera right, and fitted with its white insert). That
produced most of the light on the right, and some of the catch lights in the eyes.

photo © Andrew Darlow

Tip #98

Create a Hand-Colored Look in Your Images

Hand-colored black-and-white prints have been popular for over 100 years. The look can be very striking and nostalgic, but you don't need special paints or a paintbrush to do it. Almost any image editor will allow you to produce great-looking hand-colored images. The key is to use layers or other nondestructive workflow options so that you can revisit the image to increase or decrease saturation, change the overall colors, and adjust the masking if you've "painted outside the lines."

One way to get the hand-colored look is very fast and simple—just reduce saturation! Saturation can be reduced using virtually any photo editing program, and depending on how much you reduce the saturation of your image, you can make your photo look like it's from a 1970's color magazine ad, or a faded color print from the same time period. Also, as I touched on in Tip 85, any tutorial for Photoshop Elements can be done in Adobe Photoshop with the same or similar tools, and many Adobe Photoshop techniques can be duplicated in Photoshop Elements.

Another approach is to keep a dog or cat his or her natural color by masking him or her out in a photo editor. Then make the background completely neutral or a warm-toned black and white. Some links to free hand-coloring tutorials for a few different applications can be found on the companion Web site [w9.20].

For this photo of a friend's cat, I liked the look of the cat but didn't like some of the strong colors in the background. I decided to retain some color by reducing the overall saturation in the image. I then just selected the cat's eyes and made them a more aqua color tone using Adobe Photoshop's Replace Color tool (go to "Image > Adjustments > Replace Color").

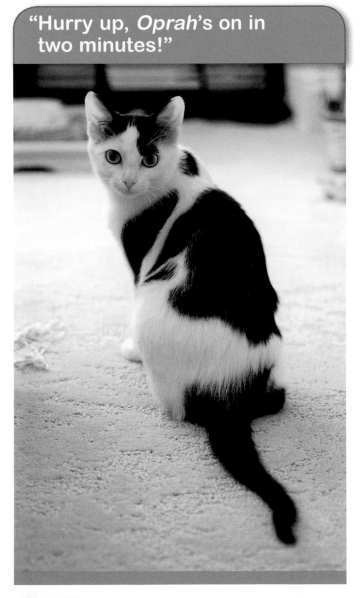

"Hurry up, *Oprah*'s on in two minutes!"

 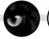

Camera: Canon EOS-D60;

Lens/Focal Length: Canon 50mm macro;

ISO: 200; *Aperture:* f/2.8;

Shutter Speed: $\frac{1}{45}$ sec;

Lighting Notes: Lighting came primarily from natural daylight from a few windows located camera left, and in front of the cat.

photo © Andrew Darlow

Tip #99

Consider Ordering Continuous-Tone Prints from a Photo Lab or Retail Store

182

Continuous-tone digital prints from photo labs or from many of the retail stores that offer this type of printing are a great choice for a few reasons:

1. You can have sharp, vibrant, long-lasting prints made afford-ably from wallet size to over 40 × 60 inches.

2. The prints are very water- and smudge-resistant and have an expected longevity of about 20–60 years if displayed under typical gallery lighting (much longer in dark storage) before noticeable fading or color shift based on longevity testing from Wilhelm Imaging Research. Prints made on some types of photo papers fared better than others, as you can see on their Web site [w9.21].

3. There are many online companies that offer continuous-tone digital printing, including Shutterfly, Snapfish, Kodak Gallery, and others [w9.22].

There are some steps you can take to help ensure that you get consistent, high-quality results from your lab, and I've written an article that covers the topic in depth [w9.23]. One important part of the article includes using a standard image to test all of your devices from monitor to print. An example of a good standard image is shown below, and the link to download it can be found in the article.

For more info, visit www.PhotoPetTips.com or www.ImagingBuffet.com

Images from Fuji and Kodak test targets. Sepia image © A. Dar

Tip #100

Make Your Own Prints at Home or in Your Studio

The subject of making prints from digital images is a topic very near and dear to my heart. There is nothing like making a print of your dog or cat, framing it, and giving it to a friend or another member of your family. The options for printing at home are extensive, and there are many options, from small printers that you can take anywhere and that are made primarily for printing 4 × 6-inch (approx. 10 × 15cm) prints, to printers that can output fine-art prints 64 inches (163cm) in width or larger.

Many books have been written on the topic of printing digital images, and I can recommend at least one from someone I know pretty well! Seriously, I've linked to a number of books and articles on the companion Web site that can help with choosing and using inkjet and other printers [w9.24]. One of the articles is entitled "5 Things to Consider before Buying Your Next Inkjet Printer." Other articles and resources take you step-by-step through the printing process. The issue of print longevity is one of great importance to many people (including me), and that is covered in detail in many of the articles, as well as on the Web site of Wilhelm Imaging Resource [w9.25].

The standard image file shown on the opposite page contains color and black and white images sized to 280 PPI on a 4 × 6 inch (approx. 10 × 15cm) canvas and saved with the sRGB working space. The file is in the sRGB working space and Photoshop PSD format so that you can experiment without degrading the image quality (saving a JPG on top of a JPG is not advisable because you will be creating more and more artifacts each time). The image also includes some text, which helps to judge the sharpness of the lab's output.

Please Note: For this system to work properly, it is important to instruct your lab to turn off any color correction (most labs keep correction on by default), or you won't be able to properly control the color and density of your prints. It is also important to view your prints under controlled lighting (about 4000–5000 degrees Kelvin is recommended). See Tip 91 earlier in this chapter, and Chapter 1, Tip 4, for more on the importance of lighting and color temperature.

photo © Andrew Darlow

The Highest Standard of Care: Sub-Zero Cold Storage For Small Personal Collections to Large Institutional Archives	WIR Technical Articles About Image Permanence Test Methods and the Permanence of Digitally-Printed Photographs	WIR Print Permanence Ratings for 3rd Party Consumer Inks/Papers and General Interest Image Permanence Articles	WIR Print Permanence Ratings for Desktop Printers, 4x6-Inch Dedicated Photo Printers, and Silver-Halide Digital Minilabs	WIR Print Permanence Ratings for Medium-Format Tabletop Inkjet Photo Printers and for Large-Format Inkjet Photo Printers

Just Posted!

"Long-Term Preservation of Photographic Originals and Digital Image Files in the Corbis/Sygma Collection in France"

By Henry Wilhelm (WIR), Cédric Gressent (Corbis/Sygma France), and Drew MacLean (Corbis USA)

View 9-page Article
From IS&T's Archiving 2008 Conference
in Berne, Switzerland
June 2008
Posted May 10, 2009

Download 9-Page PDF
From IS&T's Archiving 2008 Conference

Corbis France Press Release May 15, 2009:

"Corbis Opens Sygma Preservation and Access Facility"

Download 2-Page PDF
Choose Language:
English Chinese

Article from IS&T NIP22: 2006 International Conference On Digital Printing Technologies

Denver, Colorado USA
September 19, 2006

"A 15-Year History of Digital Printing Technology and Print Permanence in the Evolution of Digital Fine Art Photography"

By Henry Wilhelm

View 9-page Article
Download 9-page PDF
Posted September 25, 2006

Essay Excerpted from the Book "Nash Editions: Photography and the Art of Digital Printing"

By Graham Nash with essays by Richard Benson, R. Mac Holbert, and Henry Wilhelm Edited by Garrett White

"A History of Permanence in Traditional and Digital Color Photography: The Role of...

Press Release

"Premier Imaging Products and Wilhelm Imaging Research Announce Comprehensive Testing of PremierArt GenerationsFine Art Papers and Canvas"

Go To Press Release
Posted March 2, 2009
Download 1-Page PDF

Print Permanence Ratings for Harman Inkjet Papers with HP, Epson, and Canon Pigment Inks

View 8-page Article
Download 8-page PDF
Posted October 22, 2008

Print Permanence Ratings for Hahnemuhle Inkjet Papers with Epson UltraChrome K3 Pigment Inks

Article from IS&T's 2007 International Symposium On Technologies For Digital Fulfillment

Las Vegas, Nevada USA
March 5, 2007

"A Survey of Print Permanence in the 4x6-Inch Consumer Digital Print Market in 2004-2007"

By Henry Wilhelm

Includes WIR Data for the NEWEST 4x6-inch Printers from Dell, Lexmark, Canon, Hewlett-Packard, and Epson

Also Includes WIR Display Permanence Ratings for Digital Minilab Silver-Halide Color Papers:

WIR/DPR Ratings (Years)
(40) Fujicolor Crystal Archive
(19) Kodak Edge Generations
(17) Konica (DNP) Impresa

View 7-page Article
Download 7-Page PDF
Posted March 7, 2007

HP Photosmart Express PE1000 Retail Kiosk Printer with HP Vivera Pigment Inks

Print Permanence Ratings for HP Designjet Z3200 Printer and Vivera Pigment Inks With Chromatic Red Ink

HP Designjet Z3200
Full-Screen Page View
Posted March 25, 2009

HP Designjet Z3200
Download 7-Page PDF

Print Permanence Ratings for Epson Stylus Photo R2880 Printer and New UltraChrome K3 With Vivid Magenta Inks

Epson Stylus Photo R2880
Full-Screen Page View
Posted February 16, 2009

Epson Stylus Photo R2880
Download 8-Page PDF

Print Permanence Ratings for Epson Stylus Pro 7900 Printer and New UltraChrome HDR Inks

Tip #101

Find More Online Resources, Experiment, and Have Fun!

Learning the ins and outs of a digital camera, imaging software, and working with a photo lab or your own printer can get frustrating at times. Always know that there are others who are probably experiencing the same problems, so I've put together a list of online photo-related forums and groups to consider visiting [w9.26]. Also use search engines—they can be invaluable. If a certain search term doesn't get your question answered, try a different one with quotes; for example, "Adobe Photoshop sharpening" and "sharpening with Adobe Photoshop" will give you some of the same links, but many will be different.

And most of all, have fun! Dogs, cats, and our family and friends have a way of bringing out the most wonderful emotions in us, and photography helps us to cherish and share those special moments in so many ways.

Wilhem Imaging Research (wilhelm-research.com) has a wealth of good information, not just about longevity testing, but also about the technology and inks used in the printers that are discussed. The right column contains most of the information regarding late-model inkjet printers. You can view the information on-screen or download PDFs.

Index

Index

189

Index